IMAGES
of America
SURFSIDE

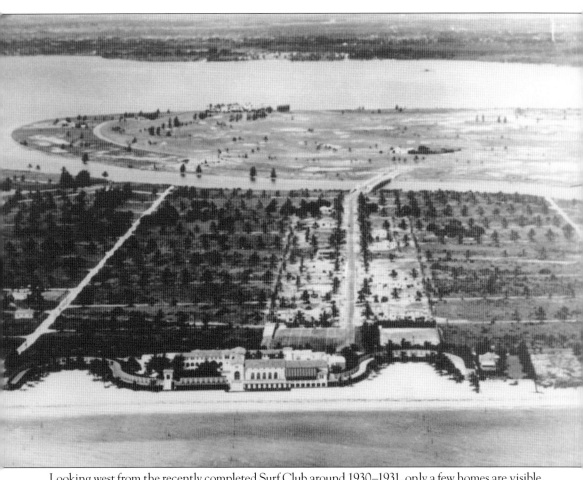

Looking west from the recently completed Surf Club around 1930–1931, only a few homes are visible. Indian Creek Island is connected to Surfside by a bridge, while the vast expanse of northeast Dade County, in the far background, is completely undeveloped. (Courtesy The Bramson Archive.)

ON THE COVER: This marvelous view of Surfside looks south on Collins Avenue from the roof of the Americana Hotel on June 26, 1968. (Courtesy The Bramson Archive.)

IMAGES of America
SURFSIDE

Seth H. Bramson
Foreword by Mayor Daniel Dietch

Copyright © 2015 by Seth H. Bramson
ISBN 978-1-4671-1457-8

Published by Arcadia Publishing
Charleston, South Carolina

Printed in the United States of America

Library of Congress Control Number: 2015935036

For all general information, please contact Arcadia Publishing:
Telephone 843-853-2070
Fax 843-853-0044
E-mail sales@arcadiapublishing.com
For customer service and orders:
Toll-Free 1-888-313-2665

Visit us on the Internet at www.arcadiapublishing.com

Contents

Foreword		6
Acknowledgments		7
Introduction		8
1.	Henry Levy and Normandy Beach	11
2.	The Surf Club	19
3.	Becoming a Town	29
4.	Collins Avenue and Harding Avenue	37
5.	Buildings, Businesses, and Stores	47
6.	The Community Center	59
7.	Hotels and Motels	65
8.	Surfsiders	93
9.	Our Friends and Neighbors	113
10.	Taking Surfside into the Future	119
About the Author		127

Foreword

Welcome to the first-ever book on and about the history of Surfside, Florida. Surfside is a unique coastal community nestled between the city of Miami Beach to the south; the village of Bal Harbour to the north; the village of Indian Creek, the Intracoastal Waterway, and the town of Bay Harbor Islands to the west; and the Atlantic Ocean to the east. Since its incorporation in 1935, Surfside residents and visitors have contributed to and experienced its rich history and witnessed its evolution into a beloved community in which to live, work, visit, raise a family, and enjoy life.

Throughout its history, Surfside has been home to and the host of many iconic figures. In the late 1940s, Winston Churchill was a frequent guest of the Surf Club. In 1964, Sonny Liston trained for his historic fight against Cassius Clay at the Surfside Community Center. Nobel laureate Isaac Bashevis Singer resided here in his later years, until his passing in 1991. In addition, renowned songwriter Sid Tepper and his family lived here from 1971 to 1997. Surfside is also home to historic and culturally significant establishments, including the Surf Club and The Shul, as well as other architecturally important properties designed by renowned architects Russell Pancoast, Wahl Snyder, Igor Polivetsky, Richard Meier, Bernardo Fort-Brescia, Luis Revuelta, and Robert Swedroe.

Surfside continues to evolve through proper planning, sensible developmental controls, appropriate oversight, and stewardship. Surfside is currently experiencing a revival of new hotel development so visitors can fully enjoy and appreciate its coastline. The town's business district is similarly thriving, with many beautification projects and new businesses supporting the community's needs. At the same time, the multifamily and single-family districts are benefitting from homeowners' investments in their properties, in turn improving the quality, functionality, and aesthetic of Surfside's housing stock. Surfside is truly experiencing a renaissance.

Surfside has so much to be proud of, including its vast recreation programs, beautiful beaches and parks, a diverse downtown shopping district, caring residents, and a town staff dedicated to serving the community and its residents. As Surfside's mayor, I could not be prouder of its history, its residents, and the many engaged stakeholders helping to shape a very exciting future. By working collaboratively to responsibly manage the needs and desires of the community, we are collectively putting "the shine back in Surfside."

<div style="text-align:right;">
Warmly,

Daniel Dietch

Mayor, Town of Surfside
</div>

Acknowledgments

Fortunately, this is not a "Where do I start?" situation for the acknowledgments because it is without question that I express my appreciation for help and assistance to, first, Surfside mayor Daniel Dietch and his wonderful wife, Dana Kulvin, who was vice chair of the Surfside 75th anniversary committee. Both immediate past town manager Michael Crotty and his executive assistant, Dawn Hunziker, were most gracious and never failed to welcome me warmly. Town clerk Sandra Novoa was of great help and shared many of Surfside's historical photographs with me. Duncan E. Tavares, tourism, economic development, and community services director, was always of help, and Chief of Police David Allen and his executive assistant, Dina Goldstein, graciously answered all my questions and provided me with photographs and information on the department. Former mayor Paul Novack was "only" great, and I am very grateful for his and former councilman and vice mayor Joe Graubart's help.

The story of Surfside began with the work of Henry Levy; his daughter, June Levy Newbauer, allowed me to "noodge" her endlessly as she shared all of the material that she had saved from her dear father's work in building the lower third of the town in the 1920s. This book would have been incomplete and the first chapter could not have been done without the help of Mrs. Newbauer. I am endlessly grateful to her for her gracious assistance and her friendship, and I thank her for never saying "no" and never turning down my requests to use her material.

The employees of the Surf Club, including Walid Sfeir, Barbara Levy, and Lorenzo Restivo, among others, were beyond accommodating as they allowed me to search through their incredible historical files, and I am very grateful to them for being so kind.

Both current and former Surfsiders were beyond kind in their willingness to assist, and I thank Dory Lurie, who, before leaving for California, bestowed all her and her late husband Eli's Surfside memorabilia on me. The great architect and Surfside resident Robert Swedroe furnished me with photographs of all his Surfside projects, while his wonderful assistant, Cathleen Sheeley-Thompson, provided all variety of background material and information. Famed architect Kobi Karp was always warm and welcoming and provided me with numerous Surf Club photographs and information.

A special thank-you must go to Reggie Hui and the Library of America, who were kind enough to permit me to use the cover of *Isaac Bashevis Singer: An Album* in the "Surfsiders" chapter, and I greatly appreciate their helpfulness and cooperation.

Dear and longtime friends Ricky Neross and Charlie Clark were marvelous in sharing their Surfside recollections. Famed songstress Hazel Lee, now a Surfside resident, gave me a number of fine Surfside photographs to use, and Sharon Katz Higgins sent a terrific photograph of Sheldon's Drugs. Mary Csar, of the Boca Raton Historical Society and Museum, provided me with a great early Surfside foldout image, and I sincerely thank her and all named above for their kind and generous help.

Unless otherwise noted, all photographs are from the Bramson Archive.

Introduction

What a great place to live, raise children, own a home, have an office, open a business, go out to eat or shop, and, yes, even vacation. And if one cannot find exactly what he or she needs or is looking for, a very short walk (as in right across Ninety-sixth Street) leads to Bal Harbour Shops, one of America's finest and most famous malls. Surfside is a great town.

But how—and when—did it begin? And what has happened since?

The wonderful story of Surfside began in France when Henri (Henry) Levy, disturbed by the anti-Semitism that he and other Jewish people were regularly being exposed to, moved to Cincinnati, where Levy entered the emerging movie theater business and opened a chain of cinemas. Eventually, though, the bitterly cold winters and his older daughter's health issues forced him and his family to relocate to a sunnier clime, and in 1922, they moved south, first to Miami and then to Miami Beach.

By 1924, Levy had begun to develop what he called Normandy Beach, which would, through the vagaries of development and incorporation, become the lower (southernmost) third of the newly incorporated Town of Surfside in 1935. Levy would also develop Normandy Isle in Miami Beach, as well as that city's beachfront area between approximately Sixty-fourth and Seventy-sixth Streets, calling it Normandy Beach South.

In 2001, an informational paper on the history of the northern portion of Miami Beach (also known as "North Beach") was prepared for Miami Beach's planning department. According to its author, the Normandy Beach subdivision was platted on February 9, 1924. The area included in that plat was the Tatum Brothers' third Altos del Mar subdivision. The Tatum Brothers—J.H., S.M., B.B., and J.R.—were early Miami and Miami Beach land developers and property owners who, according to the City of Miami Beach's Altos del Mar Historic District Designation Report of 1987 (referenced in the 2001 document), had purchased most of the land from what would become approximately Seventy-fifth Street in Miami Beach all the way up to the north end of Dade County on the beach side, including what would later become Surfside, Bal Harbour, possibly Haulover Beach, Sunny Isles (later, Sunny Isles Beach), and Golden Beach. Tatum Waterway and Tatum Waterway Drive in Miami Beach, north of Seventy-seventh Street, were eventually part of the Altos del Mar subdivision in what was apparently the last plat filed, in 1946.

Levy had different names planned for the various streets than those that exist in Surfside today. Bay Drive, which he showed running from Biscaya Island to Collins Avenue using both an east-west and a north-south axis, retains that name only on the north-south axis, while the east-west portion of the street was renumbered as Eighty-eighth Street. Eighty-ninth Street was to be named Lake Avenue, and Ninetieth Street, the northern limit of what would have been Normandy Beach, was to be Avondale Avenue, as Levy, according to his daughter June Levy Newbauer, wanted to commemorate one of Cincinnati's most important business thoroughfares. The small park in the triangle of streets where Collins Avenue entered Surfside was named

Clemence and June Park. Unfortunately, when Collins was widened to allow for more traffic lanes, the park disappeared.

In 1935, five years after its opening, members of the Surf Club (then a restricted private club where persons of the Jewish faith were strictly excluded from membership) incorporated a new town, which they called Surfside. Although only one square mile in size, the town packs quite a punch, with a positive influence on South Florida well beyond its relatively modest dimensions. One of its most famous residents was the great writer Isaac Bashevis Singer, for whom Ninety-fifth Street is now named. In fact, while sitting at the counter at Sheldon's Drugs on the northeast corner of Ninety-fifth Street and Harding Avenue, Bashevis received the phone call informing him that he had won the Nobel Prize for Literature.

In 1939, the residents of the island just west of Surfside (which would have been the Shoreland Company's Miami Shores recreation island had the 1926 bust not intervened, ending the great boom of the early to mid-1920s) learned that the Surfside town council was considering the annexation of their island. By that time, the island had become a private enclave of homes and a fine golf course. Word filtered onto the island that Surfside, which had been incorporated four years earlier, was casting covetous eyes across Indian Creek toward the 300 acres. In fact, Surfside had discussed the possibility of annexing it at several council meetings. Moving swiftly, the island's residents took advantage of what is now a sunsetted state law, which at the time allowed any group of 25 or more people living "relatively contiguously" to form a municipality. On May 19, 1939, the island was incorporated as Indian Creek Village, and Surfside's plans for expansion ended.

The town continued to grow, though, as homes and apartment houses were built and the various municipal departments came into existence, including public works, police, and recreation. Eventually, a volunteer fire department was formed. Harding Avenue, from Ninety-fourth to Ninety-sixth Streets, and Ninety-fifth Street, from Harding to Collins Avenue, became an increasingly busy and well-patronized business district. In 1954, through the efforts of the town and the Surfside–Golden Beach Jaycees, a US post office was built and opened on Ninety-fifth Street between Harding Avenue and Collins Avenue.

Although not as grandiose or architecturally kitschy as those of Miami Beach or Sunny Isles or as staid as those in Bal Harbour, a good few hotels and motels sprouted along Collins Avenue, from Eighty-eighth Street north to Ninety-sixth Street, interspersed with apartment houses on both sides of the street, as well as on Harding Avenue. Homes were built on and generally west of Harding Avenue, the town becoming a highly desirable residential address.

Today, Surfside is an upscale community with a nationally accredited police department, town manager, mayor, and council who have set the highest standards for ethics in government and departments, such as public works and recreation, which are appreciated and even loved by the town's residents. In effect, Surfside has become synonymous with quality, and Mayor Daniel Dietch and town manager Guillermo Olmedillo insist that the town's residents and visitors are treated with the utmost level of courtesy and respect. For visitors, the town's Tourism Department, under the direction of Duncan Tavares, has done an outstanding job not only attracting visitors but also making them feel welcome as soon as they arrive.

From a major supermarket chain to restaurants, clothing stores, a travel agency, banks, and numerous specialty shops, as well as office space for professionals in several high-quality buildings, Surfside is one of the finest communities—not just in South Florida, but in the entire state—in which to live, operate a business, and raise a family. And, indeed, it will continue as such.

One

Henry Levy and Normandy Beach

The story of Surfside does not begin with either the Surf Club or the town's incorporation in 1935. Rather, it begins, oddly enough, in Hochfelden, Alsace, France, where Henri (Henry) Levy was born on October 20, 1883. In 1900, when Henri was 17, the family immigrated to the United States, settling in Cincinnati.

There, Henry would meet Rose Stecker, a Kentuckian and noted millinery designer. Charmed by Henry, she married him following a suitable courtship. Intrigued by the nascent film industry that was just beginning to develop in America, he would eventually own a major chain of movie theaters in Cincinnati.

Henry and Rose had two daughters, Clemence and June. The bitterly cold Ohio winters were harsh on Clemence, and in late 1922, Levy moved his family to a small resort area known as Miami. The following year, the Levys purchased a sizeable lot, and in 1924, Henry had a coral rock house built at 1030 Washington Avenue in Miami Beach. It was in that house that June Levy Newbauer and her sister Clemence grew up and in which she and the family lived until 1940.

According to Newbauer, her father purchased property toward the north end of Miami Beach. Levy would eventually develop three separate sites, the first of which would be Normandy Beach, later known as Surfside.

In 1925, Levy platted Normandy Beach South, which ran from Sixty-fourth Street to Seventy-sixth Street in Miami Beach. Levy's third and final development would be Normandy Isle, a major business and residential area of Miami Beach traversed by Seventy-first Street on the beach side and by the Seventy-ninth Street Causeway coming from the Miami side.

Normandy Beach, including the Levy-built Biscaya Island, is what would eventually become the lower third of Surfside. Hence, that must be the main focus here.

In 1938, Henry Levy died unexpectedly of complications from ulcers following a trip to France. With his death, Miami Beach and Surfside, as well as his family, lost a great man, but the promise and beauty of Normandy Beach would, within several years, live on as the town of Surfside.

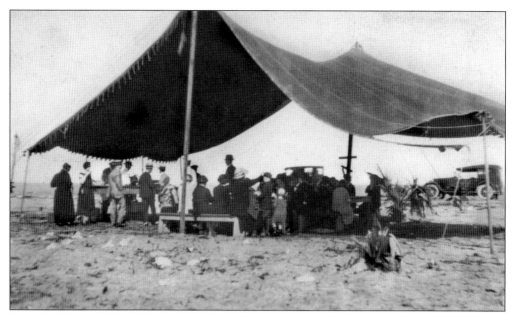

This is the original "sales office" for the Normandy Beach development of Rose and Henry Levy. Like almost all the other Greater Miami developers during the great Florida boom years of the early to mid-1920s, the Levys provided refreshments for prospective buyers. Although a bit grainy, taken with a box camera of the era, it is one of very few photographs that exist showing the early sales efforts of Normandy Beach. (Courtesy June Levy Newbauer.)

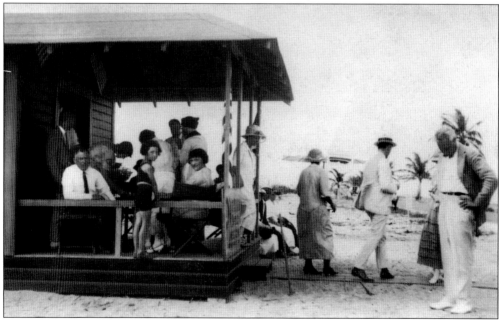

The Levy family referred to this building as "the selling shack" during the property sales phase of Normandy Beach. While most of the people in this photograph are unidentified, June Levy Newbauer's sister Clemence is standing on the outside of the railing, looking toward the camera, while their mother, Rose Levy, is seated to Clemence's right, also facing the camera. (Courtesy June Levy Newbauer.)

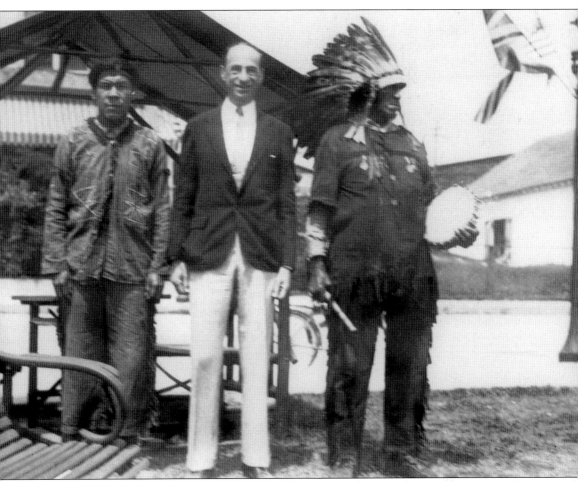

Henry Levy was a firm believer in publicizing his Normandy Beach development, much like George Merrick of Coral Gables, Carl Fisher of Miami Beach, Merle Tebbetts of Fulford by the Sea (later, North Miami Beach), and so many other early developers. Levy is shown in the middle, flanked by two Seminole Indians, one of whom, the man on the right, is believed to be the famous Jack Tigertail, also known as Chief Willy Willy. It was he who modeled for the Indian statue that publicized Glenn Curtiss and James A. Bright's Hialeah during its building stages. (Courtesy June Levy Newbauer.)

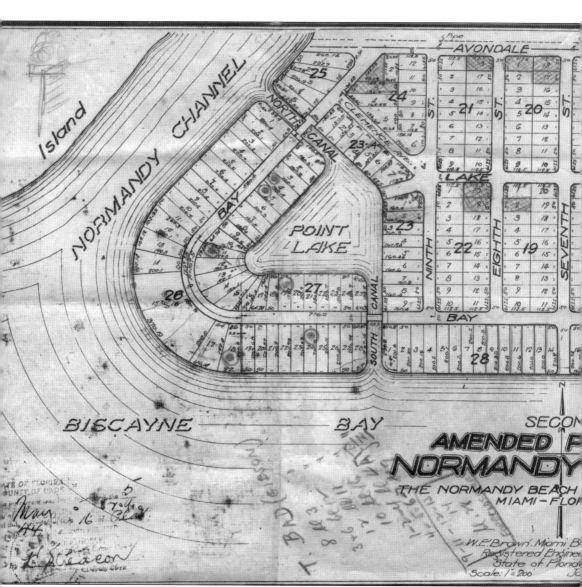

June Newbauer has, happily for history and posterity, preserved not only her family's photographs of their various developments but also the plats of Normandy Beach. This amended plat of Normandy Beach from January 1925 includes several items of note: The island at far left, not yet identified as Biscaya Island, has two bridges in the plat, but the north canal bridge was never built.

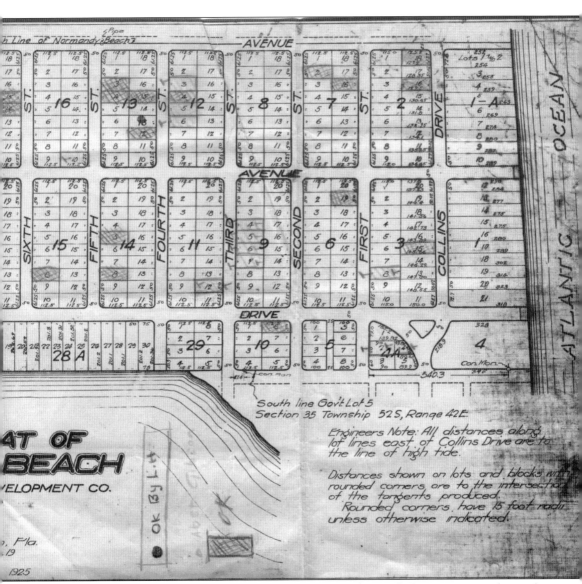

Clemence Avenue, the short diagonal street just above North Canal, does not exist today, and while Bay Drive is the name of the westernmost street in Surfside, none of the other street names or numbers were retained when Surfside became a town. (Courtesy June Levy Newbauer.)

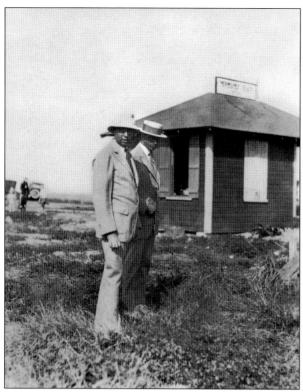

Normandy Beach Development Company's construction engineer Lassiter stands with Henry Levy in front of the sales building. The sign on the roof, although difficult to read, does have the name of Levy's company on it. June Newbauer believes that Levy is on the left in this very rare 1924 photograph, while Lassiter is on the right. (Courtesy June Levy Newbauer.)

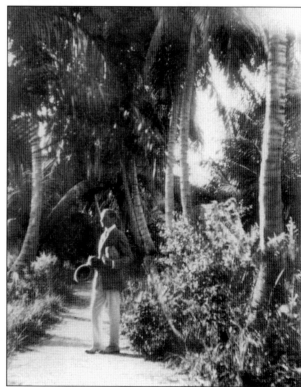

Surrounded by coconut palms and other Florida flora, Henry Levy is shown with two ripe coconuts in his hands on what is most likely Miami Beach. (Courtesy June Levy Newbauer.)

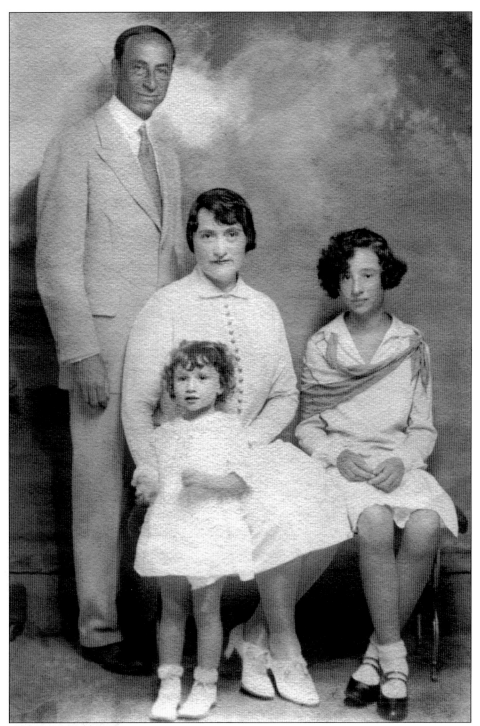

Very few Normandy Beach photographs are known to exist outside of June Newbauer's possession—hence June's collection must be cherished. One of her favorite images is this family photograph taken shortly after the Levys arrived in Miami Beach. Henry is standing at left, Rose is holding younger daughter June, and Clemence is seated next to her mother. (Courtesy June Levy Newbauer.)

KNOW ALL MEN BY THESE PRESENTS: That the Normandy Beach Development Company, an Ohio Corporation, has caused to be made, thru its President and Asst. Secretary, the attached, "SECOND REVISED PLAT OF BLOCKS 26-27 OF 2ND. AMENDED PLAT OF NORMANDY BEACH," the same being a Second Revised Plat of the, "Revised Plat of Blocks 26-27 of 2nd. Amd. Plat of Normandy Beach," as recorded in P.B. 139 at page 20, public records of Dade County, Florida.

The express purpose of this plat is to subdivide into lots the various Tracts as shown on the above mentioned plat and to correct certain errors and omissions appearing thereon. Bay Drive as shown thereon, together with all existing and future planting, both trees and shrubbery, is hereby dedicated to the perpetual use of the public, for proper purposes, reserving however to the Normandy Beach Development Co. its successors or assigns, the reversion thereof, if and when discontinued by Law.

In Witness Whereof, The Normandy Beach Development Co. thru its President and Asst. Secty. has caused its name and official seal to be affixed hereto.

NORMANDY BEACH DEVELOPMENT COMPANY.

Witnesses:

Henry Levy PRES
Louis Heiman ASST SEC

STATE OF FLORIDA, SS.
COUNTY OF DADE.

While the final plat for Normandy Beach as part of the Town of Surfside is provided in chapter three, this image shows a provision included on the plat, as well as Levy's signature, shortly before he passed away in 1938. The development company would be dedicating all plantings to "the perpetual use of the public." (Courtesy June Levy Newbauer.)

Two

The Surf Club

It is likely that the Surf Club, designed by Russell T. Pancoast in 1929, is the oldest existing building in Surfside. That, of course, is dependent on how much of the original building remains once the new combination hotel and residential edifice has been constructed on the club site. The venerable club, a throwback to the glorious days of the ultra-exclusive and completely restricted private clubs, is in the midst of a transformation that will, according to the plans, restore part of the historic Mediterranean Revival building and replace the rest with three gleaming hotel and condominium towers.

The history of the club, from its 1930 opening, has been long and colorful and predates the founding of Surfside. According to *Miami Herald* writer Andres Viglucci, Pancoast designed the club in the highly ornate and authentically detailed and proportioned Mediterranean style then in vogue, with vaulted and beamed ceilings, majestic colonnades, and massive fireplaces.

Though it lacked a golf course, the club boasted a broad stretch of virgin beach and quickly established itself as an exclusive center of social activity, beach lounging, and dinner and dancing for local grandees and equally grand winter visitors, including the duke and duchess of Windsor and, later, stars such as Elizabeth Taylor. But its most famous guest was Winston Churchill, who spent his time there painting seascapes.

The building's greater maintenance requirements combined with the club's shrinking membership base eventually led to the sale of the historic Surf Club. An agreement was reached whereby its members received a $116 million buyout from the Koc Group, a Turkish conglomerate. Under the terms of the deal with Koc and its local partner, Fort Capital Management, the proprietorial members would receive lifetime memberships to the new Surf Club, and its amenities would be available for visitors.

Perhaps best of all, the developers promised direct beach access through the club's central hallway, from Collins Avenue to the waterfront, as well as public beach access at the ends of Ninetieth and Ninety-first Streets, which are heavily used by town residents to reach the beach and the ocean.

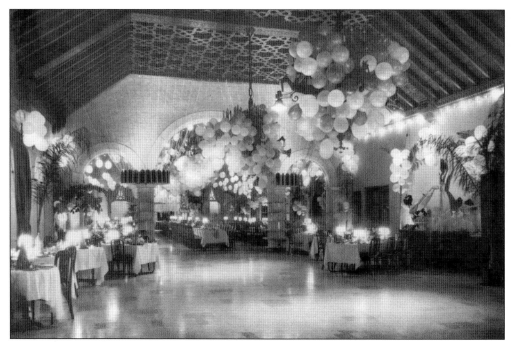

Almost from day one, the Surf Club was a whirlwind of activity for its members and their guests during the winter season. On February 10, 1934, the club sponsored its annual Mardi Gras dinner dance, with the Crystal Ballroom gloriously festooned for the occasion. (Courtesy the Surf Club.)

The club boasted a star-studded list of members and guests with political, social, and business affiliations. In this c. 1939 photograph taken on the rear patio are, from left to right, Mrs. Reuter, Mrs. Dow, and Mrs. Reuter. Regretfully, the ladies' first names were not included on the back of the original photograph. (Courtesy the Surf Club.)

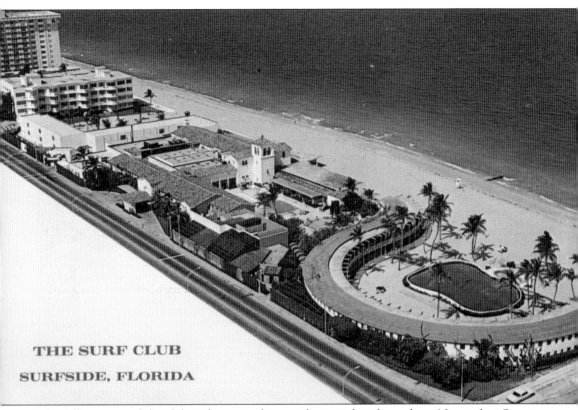

The full expanse of the club is shown in this aerial view taken from above Ninety-first Street looking north on Collins Avenue.

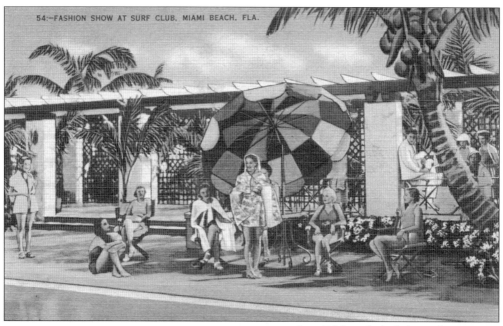

A c. 1936 poolside fashion show provides a glimpse of the resort wear styles of the era. Members were often treated to such events, along with parties and other functions.

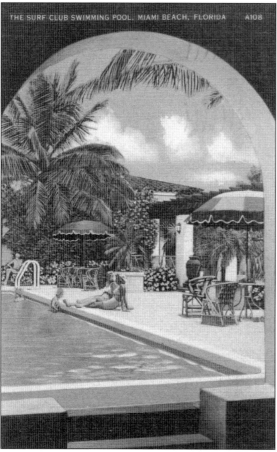

The club's pool deck is pictured here in 1940. This pool was used not only for members' daily enjoyment but also for numerous advertising photo shoots.

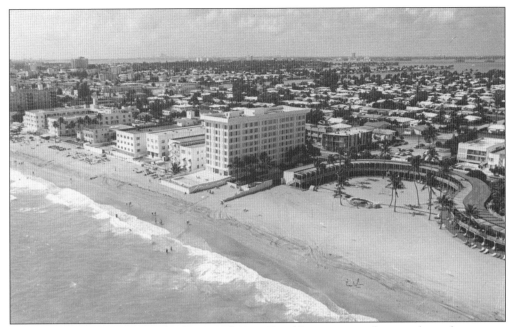

A marvelous aerial view, taken by the City of Miami Beach's engineering division, shows the expanse of the Surf Club's cabana club. Miami Beach's photographers captured the entire oceanfront, from Haulover Cut to Government Cut, preparatory to beach renourishment.

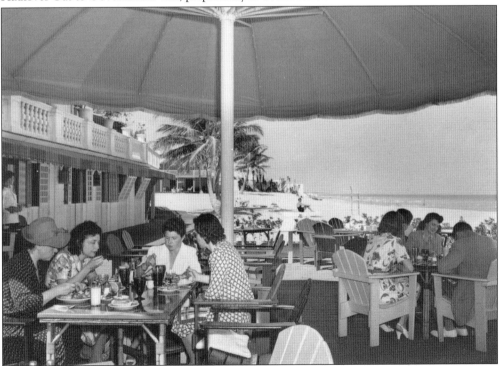

Club members are enjoying lunch at the beach terrace restaurant in 1942. In Miami Beach and Surfside, members of the only two private oceanfront clubs—the Bath and the Surf—were able to enjoy alfresco dining year-round. (Photograph by Adrien Salvas; courtesy the Surf Club.)

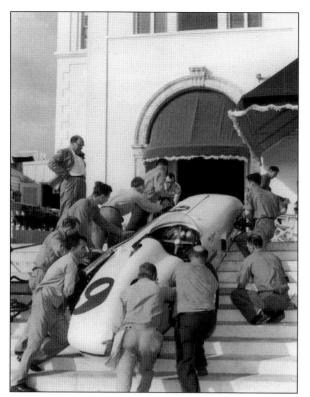

For a number of years, General Motors held special invitation-only auto premiers at the club. Shown here in 1952, a crew of 11 men carefully move a car up the front steps for display in the ballroom. (Courtesy the Surf Club.)

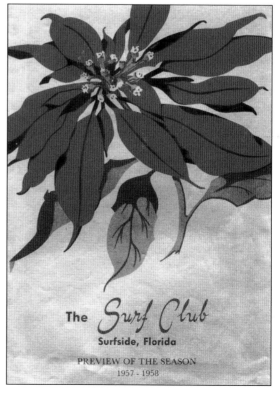

The 1957–1958 Preview of the Season booklet featured a colorful hibiscus on the cover. At the beginning of each season, members received a copy of the club's social program for that year. (Courtesy the Surf Club.)

One of the 1958 events was a costume gala, and Tom Douglass and Jean Clark are shown dressed in full regalia for the occasion. Clark, a beautiful and elegant socialite, was a longtime Bal Harbour resident. (Courtesy the Surf Club.)

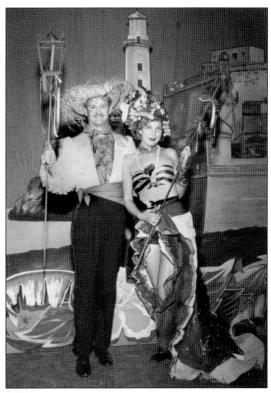

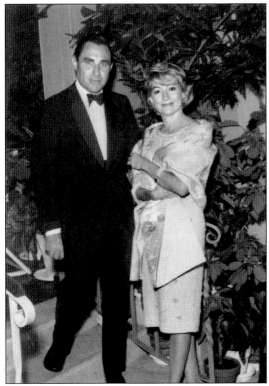

Two of "the beautiful people," Carling and Connie Dinkler, came to dinner at the club on December 16, 1961. Carling owned the hotel chain bearing his name, and together, they built Miami's famed condominium, the Palm Bay Club. (Courtesy the Surf Club.)

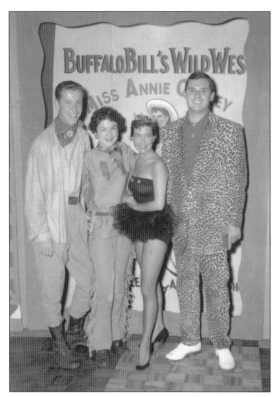

From left to right, automobile dealer Dick Fincher is shown with his wife-to-be, famous actress Gloria deHaven, and Helen and Al Quinton at the club's 1959–1960 Buffalo Bill's Wild West Show event. The club's social committee had as much fun planning the events as the members did attending them. (Photograph by Niel C. Nielsen Jr.; courtesy the Surf Club.)

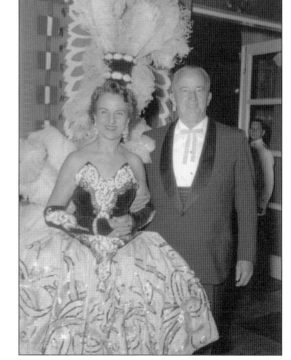

Federal judge Emmett C. Choate and his wife, Margaret, pose happily at the same Buffalo Bill's Wild West Show event, held during the 1959–1960 season. Many well-known local jurists and politicians were club members. (Photograph by Niel C. Nielsen Jr.; courtesy the Surf Club.)

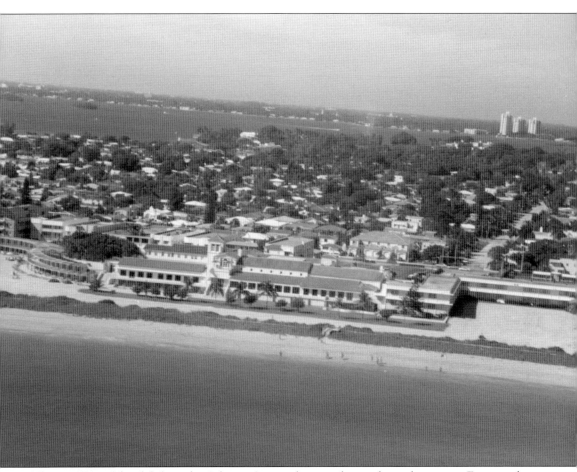

This is a view of the club from the Atlantic Ocean, showing the north-south expanse. Fortunately, the club will not only survive, although in a somewhat different physical form, it will also see a rebirth with the new buildings being constructed.

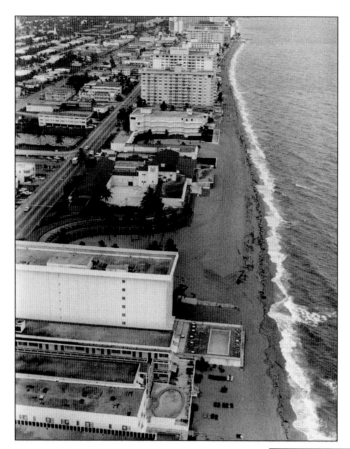

Captured by the Miami Beach News Bureau on October 5, 1970, this aerial view shows the empty property across Collins Avenue from the club. There, the construction trailers for the new Four Seasons hotel, condominiums, and club are parked while demolition, reconstruction, and the building of an entirely new facility are under way.

On Tuesday, November 4, 2014, the Four Seasons, in appreciation of the assistance rendered by the town council and its residents, invited all the town's employees, renters, and homeowners to a complimentary lunch at their food truck, which was parked in the lot across the street from town hall.

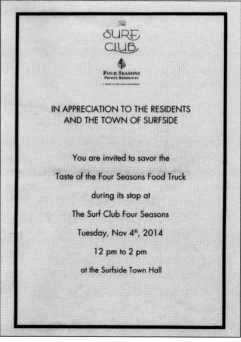

Three

BECOMING A TOWN

In 2010, Surfside celebrated its 75th anniversary with a parade and a historical display at the community center. In addition, the 75th anniversary committee published a beautiful 32-page commemorative booklet. Along with the historical material and photographs, the booklet included congratulatory letters from the mayors of Miami-Dade County and the surrounding municipalities. That event was a major part of the town's history.

Why then, 75 years prior to that celebration, did the people of what would be Surfside decide that it was necessary to incorporate their town? The 75th anniversary booklet tells the story quite well.

Miami Beach had extended its city limits to Eighty-seventh Terrace. When members of the Surf Club, some of whom were residents of Miami Beach and others residents of Indian Creek Island, learned that Miami Beach was seriously considering annexing the then-unincorporated area north of Eighty-seventh Terrace to today's Ninety-sixth Street, a group of 35 members from the privately owned club moved quickly to incorporate the area, which they named the Town of Surfside, and financed the incorporation with a $28,500 loan.

According to the anniversary publication, "Even though at the time of its incorporation Surfside boasted only fifty residents and very few buildings, the town's growth had been predetermined by the Tatum Brothers, prolific Dade County real estate developers of that period, they having subdivided what would become the town between 1923 and 1925."

Another influential individual was, of course, Henry Levy, who developed Biscaya Island and platted the lower portion (southern third) of what would become the town, from Eighty-seventh Terrace to approximately Ninetieth Street, beginning in 1924.

The first mayor of Surfside was Spearman Lewis. He and the commission envisioned a seaside town that would include resorts, homesites, and businesses, and that vision has held true throughout the history of Surfside.

Soon after incorporation on May 18, 1935, the first town hall was constructed at 9550 Harding Avenue, and until the new town hall was built, that stately edifice housed the police and fire departments, the commission chambers, town offices, and a jail. Surfside was off to a grand start.

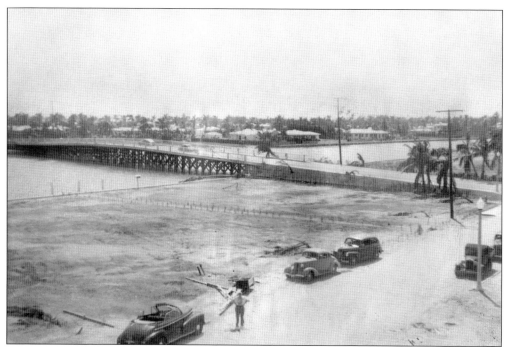

Although a bit light, this is one of the earliest known images of Surfside. This view looks northwest, with the bridge to Indian Creek in the center. Based on the cars, it appears that the photograph was taken in 1936 or 1937.

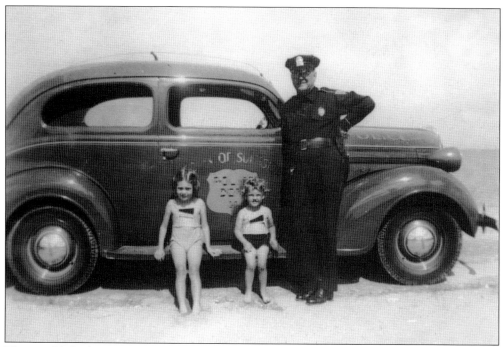

This was likely the town's first police car. Although the children have been identified as Virginia (left) and Jay Thomas, the name of the police officer is unknown. This photograph was taken in 1937, possibly by the children's parents. (Courtesy Town of Surfside.)

Dated July 1, 1935, this is the Henry Levy plat of what had become Surfside on May 18 of that year. Both the Altos del Mar and the Normandy Beach subdivisions are shown. (Courtesy June Levy Newbauer.)

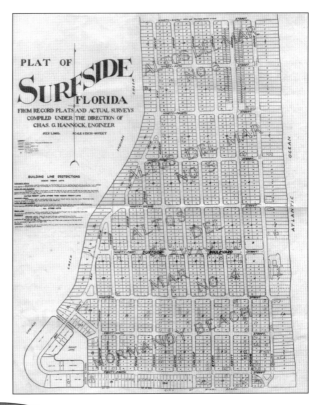

The town's official municipal seal has remained essentially the same since its adoption. It was first used in 1935 and represents the sun, sand, and surf that the town is famous for.

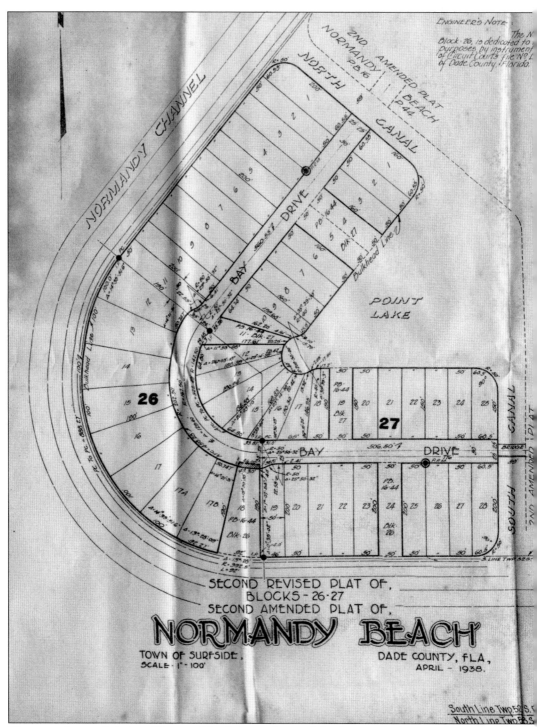

The second amended plat of Biscaya Island shows the south bridge at right but not the planned north bridge, which would have been shown at top. For whatever reason, it was never built. This plat is dated April 1938. On April 5, 1938, Levy registered his amended plat of the Normandy

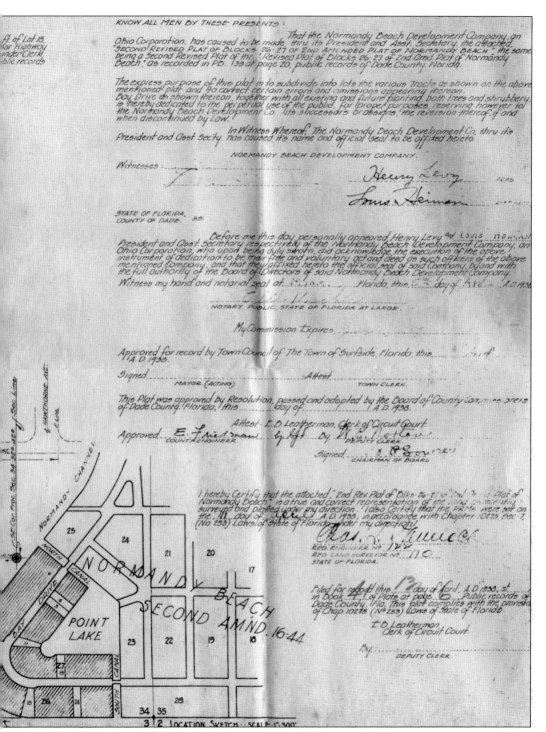

Beach subdivision with the Dade County clerk. While several of the signatures are not clear, those of Henry Levy and Louis Heiman certainly are. (Courtesy June Levy Newbauer.)

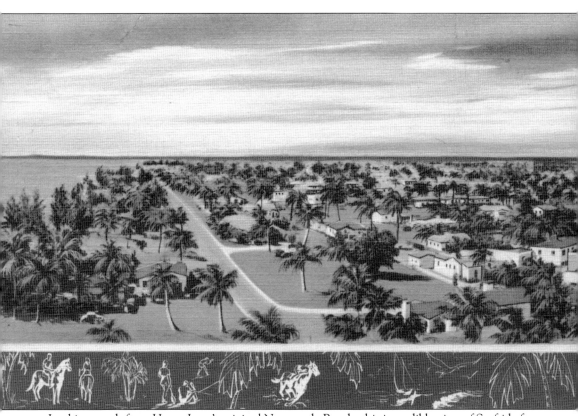

Looking north from Henry Levy's original Normandy Beach, this incredible view of Surfside from 1939–1940 was taken from Eighty-seventh Terrace, providing a marvelous panorama of the town.

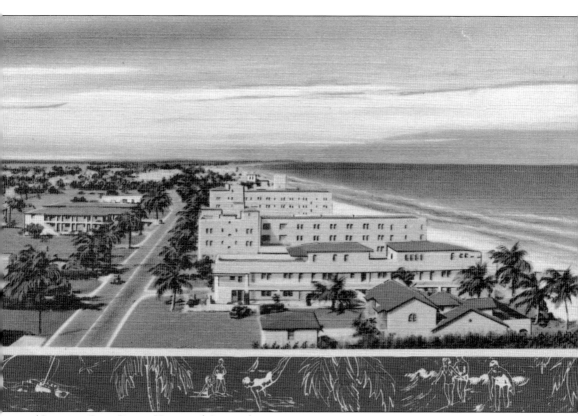
(Courtesy Boca Raton Historical Society.)

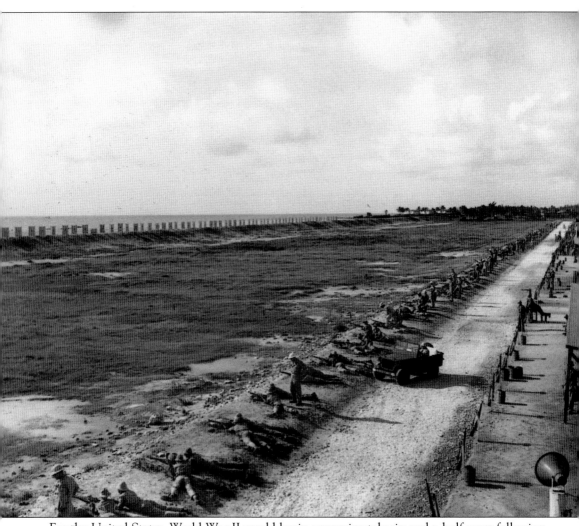

For the United States, World War II would begin approximately six and a half years following Surfside's incorporation. The nearly vacant oceanfront was ideal for use as a gunnery range for trainees of the Army Air Corps. (Courtesy Town of Surfside.)

Four

COLLINS AVENUE AND HARDING AVENUE

In Henry Levy's original plats of Normandy Beach, it is interesting to note that Collins Avenue is shown with that name, but Harding Avenue was called First Street. That, of course, would change with incorporation, as the July 1, 1935, plat for the Town of Surfside (Normandy Beach would remain the name of a subdivision, at least for a short time following incorporation) does show both Collins Avenue and Harding Avenue in place.

While Harding Avenue had been First Street, the streets were numbered consecutively from east to west during the Normandy Beach era, which changed completely once the town was incorporated. The only street to retain its name was Bay Drive, the westernmost street of Surfside.

For whatever reason, the numbered streets were changed to names. (The town's files and records do not indicate how or why the decision was made, or even who made it, but it can legitimately be assumed that it was done through a vote of the new town's council.) Harding Avenue, the first street west of Collins Avenue, was out of place in terms of the alphabetical naming system that had been adopted.

In any case, the changes were made, and the street names in Surfside are, from east to west, Collins, Harding, Abbott, Byron, Carlyle, Dickens, Emerson, Froude, Garland, Hawthorne, and Irving, all of which are avenues.

While Levy had originally given names to the streets running east and west, that too was changed with incorporation. Beginning with the first street in what had been Normandy Beach, the names were changed to numbers coinciding with those of Miami Beach. The last street at the north end of Miami Beach was and is Eighty-seventh Terrace, so the original town leaders continued the convention with Eighty-eighth Street as the first street in Surfside, and the numbers proceeded north to Ninety-sixth Street from there.

The inquisitive reader might ask why there is a chapter named for two streets, and the answer is simple: Collins Avenue and Harding Avenue are the most important streets in the town. Simply put, they are its lifeblood.

An early 1980s photograph by Allen Malschick shows the entrance to Surfside at Eighty-eighth Street and Collins Avenue. Recently deceased, Malschick was a legendary local photographer and a longtime fixture on Miami Beach.

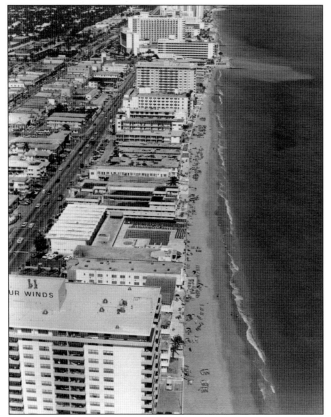

This aerial view, taken on February 19, 1969, looks north on Collins Avenue from about Ninety-third Street. In the foreground is the Four Winds condominium. The community center's pool is just north of the Four Winds, and in the background are the Singapore and Americana hotels, both in Bal Harbour, just north of Ninety-sixth Street.

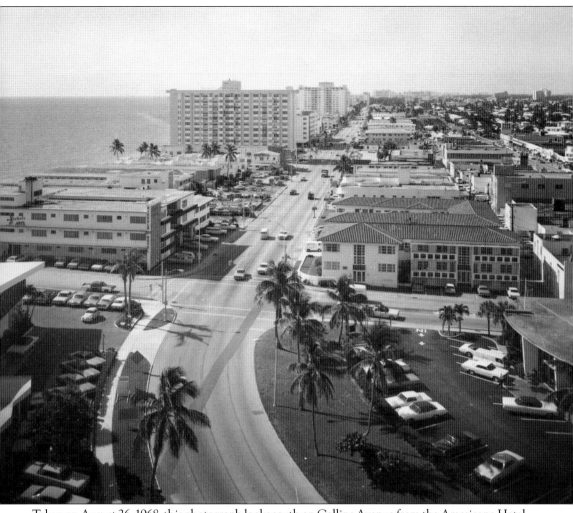

Taken on August 26, 1968, this photograph looks south on Collins Avenue from the Americana Hotel. Ninety-sixth Street is the first cross street, and the edge of what was then the Community National Bank (now Sun Trust) on the Bal Harbour side of that street is at the immediate right.

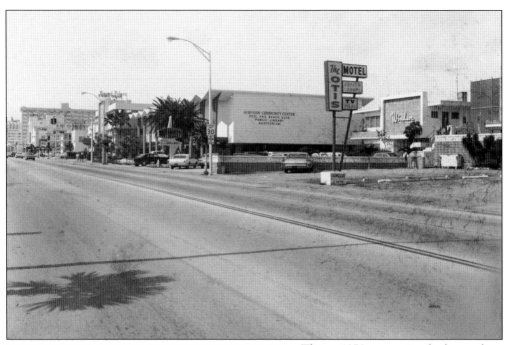

This c. 1970 street view looks north on Collins Avenue, just south of Ninety-third Street. The Windsor and Otis motels are in the foreground, with the community center and the Regent Palace motel beyond.

Felix Young was one of Greater Miami's finest and most famous restaurateurs. L'aiglon, his Surfside operation at 9585 Harding Avenue, was a major draw. The UNion 6-7601 phone number dates this piece to the late 1950s or early 1960s.

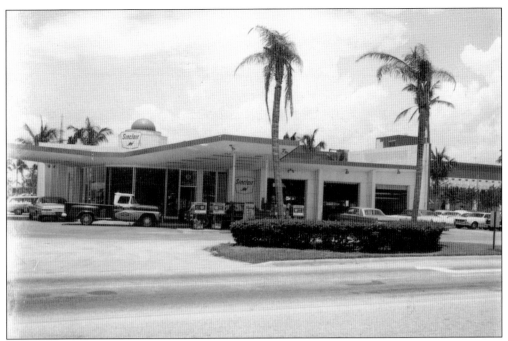

The Sinclair station was located on the northwest corner of Ninety-sixth Street and Harding Avenue. It was one of two gas stations in the four communities that make up the 33154 zip code.

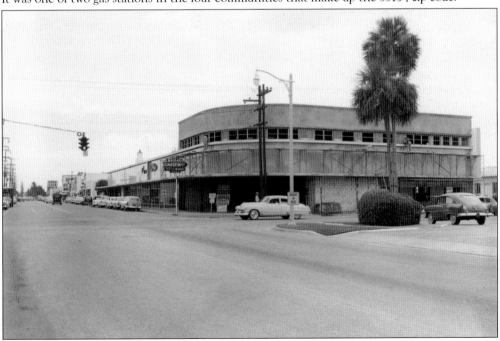

The building on the southwest corner of Harding Avenue and Ninety-sixth Street was under construction when this photograph was taken on August 10, 1955. Looking south on Harding Avenue, the Broad Causeway sign advertising the toll road from Bay Harbor Islands to North Miami is visible on the corner, and in the distance is the pylon sign for the Food Fair on the northwest corner of Ninety-fourth Street and Harding Avenue.

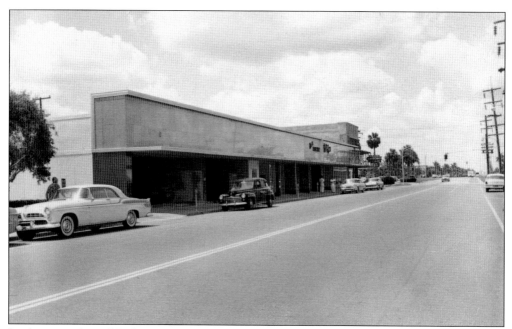

Looking north on Harding Avenue on August 10, 1955, this view shows the building under construction at Ninety-sixth Street and Harding Avenue from the opposite direction. It is now a highly desirable rental location for stores, restaurants, and offices.

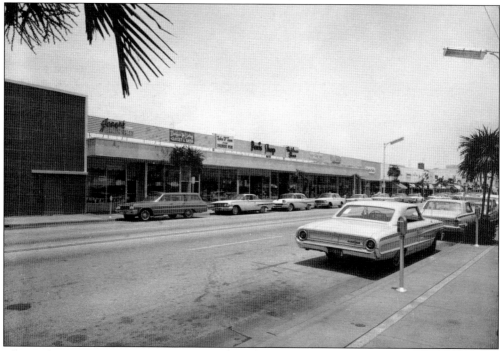

This is the west side of Harding Avenue, from just north of Ninety-fourth Street, as it appeared in 1964–1965. Among the stores are, from left to right, Joseph's Beauty Salon, Designed for Living Closet & Bath, Tykes 'n' Teens Fine Children's Wear, Paris Shop, and Red Cross Shoes. The Domino Bar and Package Store is on the same side of the street, at the end of the block.

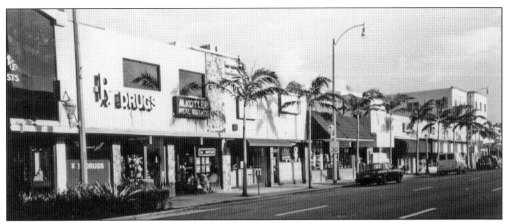

The east side of Harding Avenue is pictured in the early to mid-1970s. Only the Rx Drugs and M. Kotler Real Estate signs are readily identifiable in this photograph taken during late afternoon. The three-story structure farther south is the Trevi Building, which, for some years, was the location of the German consulate in Miami.

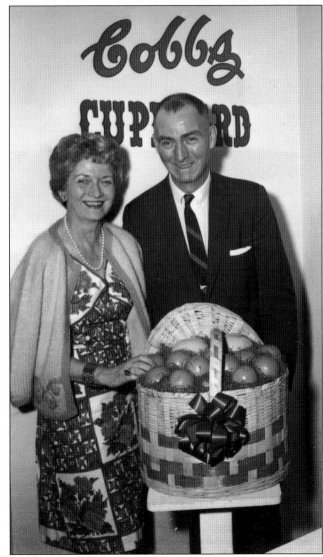

The Cobbs Fruit & Preserving Company, a famous local fruit shipper, opened Cobbs Cupboard at 9544 Harding Avenue on March 3, 1966. Two of the first customers are shown on opening day with a basket of the store's citrus fruit.

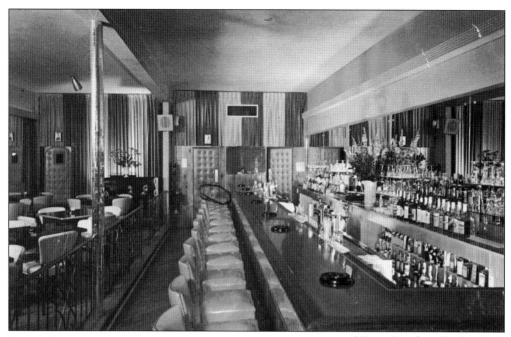

Happy Landing Cocktail Lounge was located at 9425 Harding Avenue. Owned by Ann and Phil Hughes, the lounge featured its own liquor store and advertised a "congenial atmosphere."

Pictured is the cover of Surfside's 75th anniversary booklet, a beautiful 32-page publication that details the town's history over three-quarters of a century. The anniversary committee worked on this project for nearly two years before it was published in 2010; as such, it is a cherished keepsake for Surfsiders.

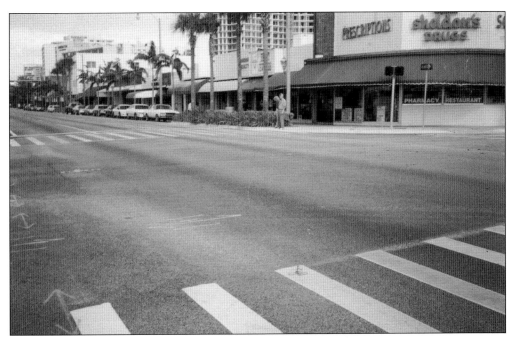

This 1980 view of the east side of Harding Avenue looks north from Sheldon's Drugs on the northeast corner of Ninety-fifth Street. Now a bank, Sheldon's was a Surfside gathering spot for many years.

Everybody loves a festival, and this was one of Surfside's regular community events. Both the children and the adults are having a grand time at the intersection of Ninety-fifth Street and Harding Avenue.

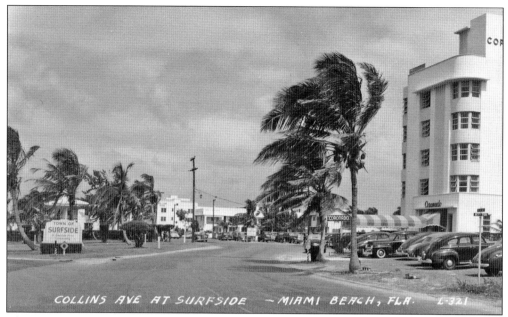

This is a truly nostalgic look back at Surfside's southern Collins Avenue entrance. The Coronado, the town's first hotel north of Miami Beach, is on the right, with the welcome sign on the left. In the right foreground is the street sign for Miami Beach's Eighty-seventh Terrace, which marks its northern city limit.

And to close this chapter, here is a wonderful panoramic view that looks south from the veterans memorial on Eighty-eighth Street, at the intersection of Collins (left) and Harding (right) Avenues. Beyond the tennis courts in the foreground is the north end of Miami Beach, stretching out across the photograph, with St. Joseph's church visible on the right.

Five

BUILDINGS, BUSINESSES, AND STORES

From its beginning, Surfside was planned as a residential, resort, and commercial community. As it grew, the vision of the original founders proved more than correct, for the town would, through the years, come to completely fulfill their dreams.

Commercial buildings and retail stores were limited to four main streets: Ninety-fifth Street, from Collins Avenue west to approximately half a block west of Harding Avenue; Ninety-sixth Street, east of Harding Avenue, on the south side of the street; Collins Avenue, north of Ninety-fifth Street, where the Shul of Bal Harbour is located; and Harding Avenue, from Ninety-sixth Street south to Ninety-fourth Street, which is the town's main and most dynamic business artery.

Harding Avenue's stores and offices have, almost from the founding of the town, run the gamut from restaurants and liquor stores to markets, clothing stores, shoe stores, jewelry stores, travel agencies, beauty salons and barbershops, real estate offices, banks, law and medical offices, and hardware stores, along with a gas station on the corner of Ninety-fourth Street and Harding Avenue. Until the new town hall was built at 9293 Harding Avenue in 1957, the original town hall was located at 9550 Harding Avenue.

Of note is the fact that, for some years, the German consulate of Miami was located in the three-story Trevi Building on the east side of Harding Avenue, between Ninety-fifth and Ninety-sixth Streets.

Perhaps the most fabled of all the businesses in Surfside was the Brook Club, long known not just for its fine food and elegant interior but also for the fact that it was, for many years, Surfside's illegal but thriving gambling venue, which featured a full casino. The repercussions of the Kefauver Committee's investigation of illegal gaming in Florida would eventually result in the club's closure, but during its years of operation, it was heavily patronized by what was known at the time as a well-heeled crowd.

Today, Harding Avenue is still thriving, with a few top-notch restaurants and numerous great stores. As always, Surfside remains a fine—and prestigious—place to shop.

Unlike the old town hall on Harding Avenue, the site of the former Surfside Social Center is unknown. Unfortunately, today's Surfsiders are unable to recall its location.

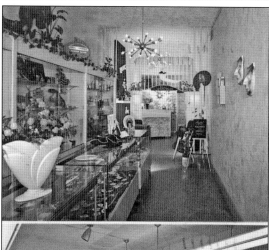

Andre's Beauty Salon at 9520 Harding Avenue was, for many years, one of the favored salons for the ladies.

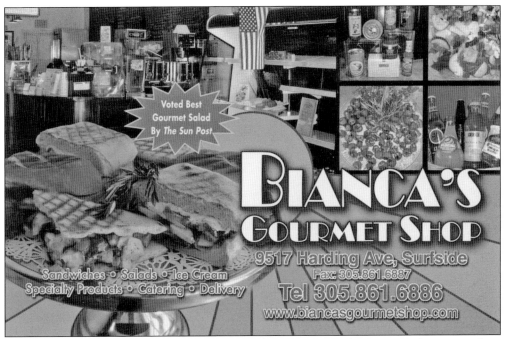

Bianca's Gourmet Shop was located at 9517 Harding Avenue, and as seen on this postcard, its gourmet salad was voted best in Miami by the *Sun Post* newspaper.

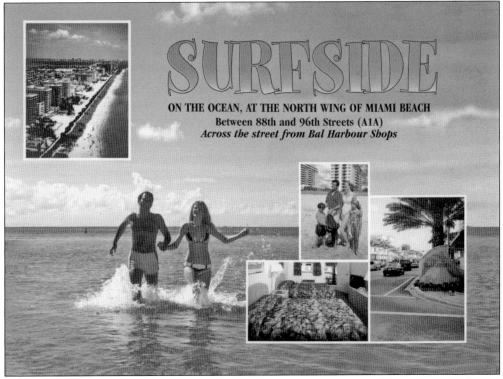

Interestingly, the business of Surfside is business. The town itself published this promotional piece touting Surfside as being a wonderful place to vacation and enjoy life.

After the Graubart family moved to Surfside, Shirley, a registered nurse, opened her electrolysis business at 310 Ninety-fifth Street, on the south side of the street, west of Harding Avenue. (Courtesy Joseph Graubart.)

SHIRLEY GRAUBART

The Surfside Blood Bank operated for a number of years, serving not only Surfside residents but also those of neighboring communities. This certificate for donating blood was presented to longtime Surfsider Dorie Lurie. (Courtesy Dorie Lurie.)

The back page of the Surfside Civic Association's *Voice* newsletter presents numerous advertisements for Surfside businesses, along with one for Miami Beach and three for the Bay Harbor Islands. Note that the ad placed by Big Daddy's Lounge spells "Surfside" incorrectly!

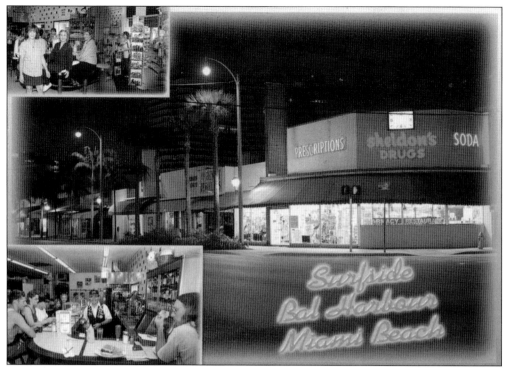

A nighttime view of Sheldon's Drugs, at the corner of Ninety-fifth Street and Harding Avenue, notes the locations of the Spector family's other drugstores in Bal Harbour and Miami Beach.

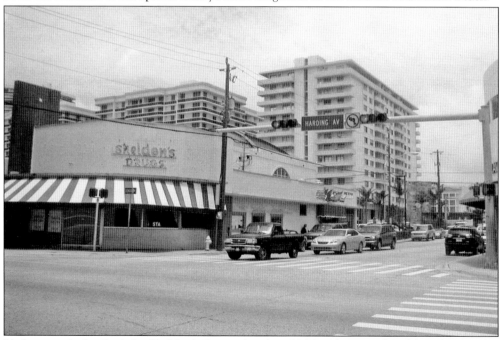

Unfortunately for Surfside, Sheldon's Drugs closed in 2005 and was replaced by a bank. This photograph, taken on May 20, 2005, shows the store after its closure, with the outline of the sign still visible. (Photograph by Sharon Katz Higgins.)

For That Special Guy CLOTHING - FURNISHINGS **MISTER GUY** 1069 Kane Concourse (96 St.) BAY HARBOR Al Fine	**NANKIN SHOE STORES** 645 Lincoln Road 163rd St. Shopping Center 73 E. Flagler Street 7573 Dadeland Mall JE 1-1616 Frank Nankin	**MELONY'S WARDROBE** Exclusive Children's Wear 9548 HARDING AVE. SURFSIDE UN 6-3601 Eden Roc & Americana Hotels 341 Miracle Mile Hank Olesky	**DARYL INDUSTRIES, INC.** MIAMI – 758-7603 Manufacturers of QUALITY ALUMINUM PRODUC MARTY LODGE
SEAVIEW CLEANERS Ladies' & Men's Tailoring 262 - 95th Street - UN 5-9623 SURFSIDE Milford Gilbert	LIFE INSURANCE PLUS "NO-LOAD" MUTUAL FUND EQUALS — SECURITY **JOE GARDNER** PL 1-0011	Largest Selection of Paperback Books, Toys & Cards in Miami Beach **CAROUSEL** **Book & Toy Shop** 9543 Harding Ave. UN 6-6126 Dick Danziger	**FUN FAIR** World Famous - Hot Dogs 1625 79th St. Causeway UN 5-5493 OPEN 24 HOURS David Kleinman
HERBERT POTASH Stock Broker Harris Upham & Co. 1085 KANE CONCOURSE BAY HARBOR ISLANDS UN 5-0511	**OFFICIAL TRAVEL CENTER** 18604 COLLINS AVENUE, MIAMI BEACH WI 5-6538 OPEN 7 DAYS TO 10:00 P.M. American Express Cards Honored Herman Blumenkranz		**Eagle Tire Co.** Distributor of **MOHAWK TIRES** 3212 N. W. North River Drive NE 4-1710 Optimist Mutsie Kratis
YOUNG SOPHISTICATES 163rd St. Shopping Center Surfside Coral Gables Fort Lauderdale Jack Lavin	**HOWARD'S SUPER LIQUORS** Fast Free Delivery - Cut Rate 515 Washington Ave. JE 8-4445 Sy Howard	Exclusive Sport and Athletic Equipment **REISLER BROS. SPORT SHOP** Oscar Reisler Ph. JE 8-1344 427 Washington Ave.	**SUPPORT OUR ADVERTISERS!!**
SIDNEY NEROSS INSURANCE INDUSTRIES PL 1-9765	**S & K DRAPERIES** Makers of Fine Custom Made Draperies & Spreads Traverse Rods - Reupholstery 7316 N.W. 7th Ave. - PL 4-3163 Philip Stein	THAL BROS. **EPICURE** **MARKET** 1656 Alton Road, Miami Beach 9417 Harding Ave. - Surfside the complete quality food market JE 8-1861	**PERFECT T.V.** 9541 Harding Ave. UN 6-4723 - UN 6-1735 "Largest Stock of Records on Miami Beach" RADIO - T.V. - HI-FI - STEREO SALES and SERVICE
FORESIGHT CORPORATION REALTORS Mortgage Brokers 1007 Kane Concourse UN 6-9777 Robert Krinzman & Walter Purdy	**MORRIS KROOP REALTORS** Fine Homes & Apartments Sales & Rentals 9509 Harding Ave. UN 5-9811	WALTER MUROFF is back at **SURFSIDE GULF SERVICE STATION** 9401 Harding Ave. - Surfside, Fla. Phone 866-2324	**SEASIDE PAINT & HARDWARE** Agency for Wilkinson Blades 9472 HARDING AVE. SURFSIDE, FLA. UN 6-8521 Ben Teich
To Serve You Better **ALLAN LASKER SURFSIDE BOOTERY, INC.** 9537 Harding Ave., Surfside, Fla. Ben Silverman - Allan Lasker	**KENN AUTO RENTAL** R E N T - A - C A R WI 7-2424	AMERICAN AUTOMOBILE DELIVERY SERVICE INC. **SHIP-A-CAR** WI 9-0300 - UN 5-7600 16755 COLLINS AVE. Dom Spinelli	**COUNTY NATIONAL BANK** Of North Miami Beach 743 N. E. 167 Street Lee Howard Vice-President, Director
SURFSIDE DRUGS, INC. "PRESCRIPTION" SPECIALISTS 9500 Harding Ave. UN 6-0342 FREE DELIVERY 7 A.M. to Midnight CHARGE ACCOUNTS INVITED Lou Cole	**SUPPORT OUR ADVERTISERS!!**	**TRAVEL DECOR** • Gifts For Any Occasion • Personal Leather Goods for Home, Travel and Office • Luggage and Luggage Repairs 9571 Harding Ave. UN 6-2570 Warner Mitchell	**FREDERICKS FURS** 9565 Harding Ave. UN 5-2338 Jerry Lindenbaum Sid Gelfand

The Bay Harbor–Surfside Optimist Club published the *Opti-Gram* on a weekly basis. As seen here from one of the 1965–1966 issues, its back page included ads from almost every business in Surfside, along with several from neighboring municipalities. (Courtesy Joseph Graubart.)

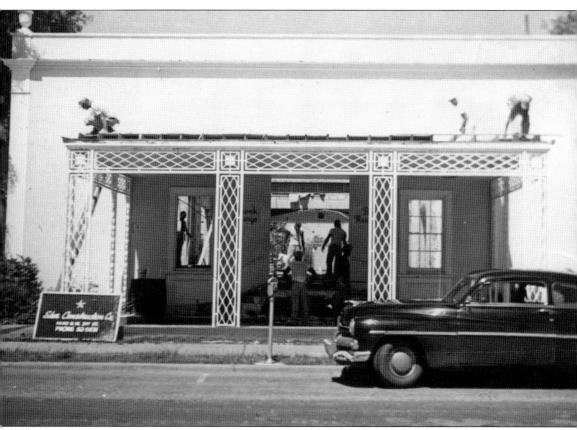

One of Surfside's most famous businesses was the Brook Club on Harding Avenue. Known for its fine food and infamous for its not-so-legal gambling casino, the club lasted well into the mid-1950s. This photograph was taken in 1952. (Photograph by Al Roth.)

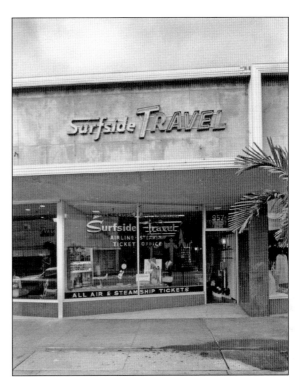

Surfside Travel at 9574 Harding Avenue was a mainstay for purchasing tickets and planning vacations. These photographs of its interior and exterior were taken on November 4, 1960.

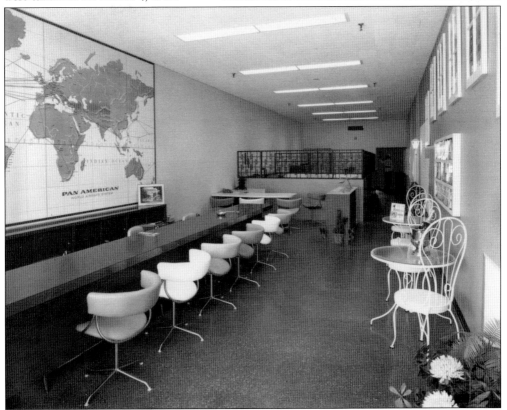

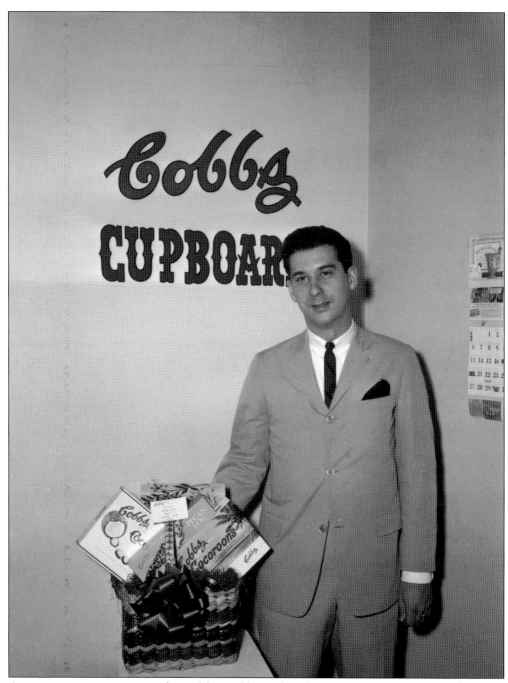

A management trainee poses in front of the "Cobbs Cupboard" sign with a gift basket of the company's products. This photograph was taken at the store at 9544 Harding Avenue on March 3, 1966.

The Surfside post office, located on the south side of Ninety-fifth Street between Collins Avenue and Harding Avenue, opened on September 25, 1954. For years, the Surfside–Golden Beach Jaycees had lobbied for Surfside to have its own post office, and their hard work came to fruition in 1954. Included with this letter was a gift and souvenir from the Jaycees and the town to commemorate the opening.

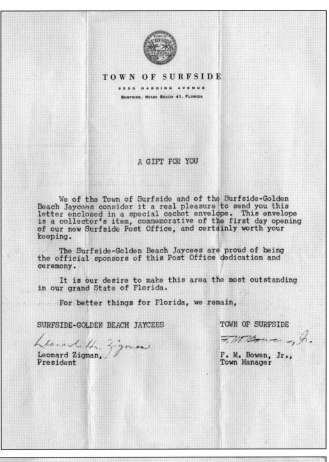

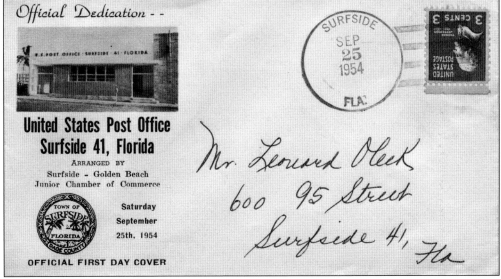

This envelope carried the cachet and first-day cancellation for the opening of the Surfside post office on September 22, 1954. Documents such as these are a true rarity for collectors of local history memorabilia.

Architect Robert Swedroe designed the 150-unit Surfside Tower at 9511 Collins Avenue. The building opened in 1970, and it is still in use today. (Courtesy Robert Swedroe.)

Surfside resident Robert Swedroe also designed the Collins-on-the-Ocean building at 9195 Collins Avenue. Opened in 1965, it was one of the town's first high-rises, with 127 units. (Courtesy Robert Swedroe.)

Six

The Community Center

A vibrant, thriving, youthful (as much in spirit as in age) community needs a central recreational facility that is accessible to all members of that area or, in the case of Surfside, the entire town.

The complete story of the community center is told in detail in the commemorative booklet of the town's 75th anniversary, and portions of this chapter have been taken from that fine 2010 publication, along with additional information provided by Duncan Tavares, director of tourism, economic development, and community services.

The idea of a central community center began when land on the southeast corner of Ninety-third Street and Collins Avenue was donated to the town in 1945. Then, in 1956, Surfside purchased the Lehman estate on the northeast corner of the same intersection. Finally, in 1958, Ninety-third Street, from Collins Avenue to the beach, was closed through the process of eminent domain, thereby providing a 160-foot frontage on both the Collins Avenue side and the beach side.

Construction of the original center began on March 15, 1962. On November 11 of that year, the facility, built in the Miami Modern (MiMo) architectural style, opened with a grand celebration attended by, among others, famous actress Jayne Mansfield.

With two swimming pools, a snack bar, several function rooms, and offices added over the years, the center drew thousands of residents and guests to its programs and children's summer camps. In 1964, then–heavyweight boxing champion Sonny Liston even trained there for his title fight with Cassius Clay.

To the chagrin of many, the community center was demolished in March 2008 due to safety concerns and other issues. Fortunately though, a farsighted council had approved plans for a two-story replacement, complete with many of the same features as the original, and much to the joy of the town's residents and visitors, the new facility opened with a gala celebration on June 19, 2011.

Most of the amenities residents had requested are now part of the new center, which promises to serve as the major recreational venue in town, as did its predecessor for 46 years.

9293 HARDING AVE., SURFSIDE, FLORIDA FEBRUARY, 1971

Something for Everyone

Surfside's Complete Community Center

Surfside boasts one of the most modern and complete community centers on the Gold Coast. The facility offers its beach for your pleasure and convenience coupled with an Olympic-Sized Swimming Pool and another pool for its younger members of the Center who cannot swim, not to mention that both pools are heated for your comfort year round.

This area is manned by professional life guards and pool boys to make your relaxation more enjoyable, a newly installed tot-lot so the youngsters can enjoy themselves also, with new equipment soon to be installed to keep them occupied as well. Sunbathing is at its highest almost year round. A luncheonette is located right in the center in case you're hungry. An appetite can build with all of the things you can do at poolside.

A newly-decorated auditorium that's available for just about every type of function or event. New sound system for perfect audio effect for everything — stage shows, plays, weddings, meetings — name it, the Surfside Community Center can accommodate it.

It also boasts classes and courses from sewing to clay sculpture to classes in stock market to help keep you occupied, so you can see that Surfside's Community Center is a complete facility for its members and residents, and just in case you are not the outgoing type, a public library can also be found. So whatever your pleasure Surfside can supply it for you.

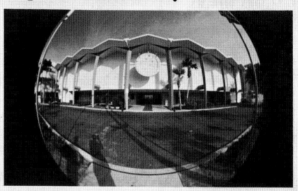

SOMETHING CAN BE DONE ABOUT POLLUTION!

Did you know that — paper can be reused? This is called recycling paper.
 — one ton of recycled paper saves 17 trees?
 — Surfside is Florida's FIRST town to sponsor a paper recycling project at the municipal level?

JOIN
SURFSIDE'S POLLUTION SOLUTION

Bring used paper and magazines to the
SURFSIDE PAPER RECYCLING DEPOT
93rd Street and Harding Avenue (South side of the Fire Station)

OPEN EVERY DAY — ALL DAY FOR INFORMATION CALL: 866-4431

In February 1971, the town's *Surfside Newsletter* carried a front-page story about the community center, which had been a dream of the town for years. (Courtesy Dorie Lurie.)

The Coronation Ball, which was the gala climax of Surfside Canada Week, was held on March 12, 1966. The two princesses flank that year's queen, one of whom is adjusting her tiara.

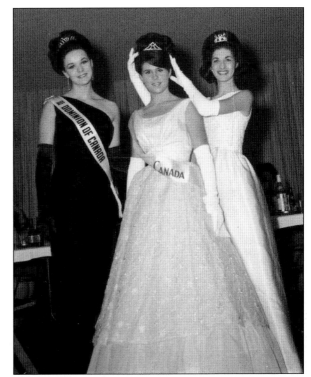

A rear view of the center shows the pool and the building's terrace. Innumerable Surfside residents, their families, and visitors enjoyed the use of the pool and its sundeck.

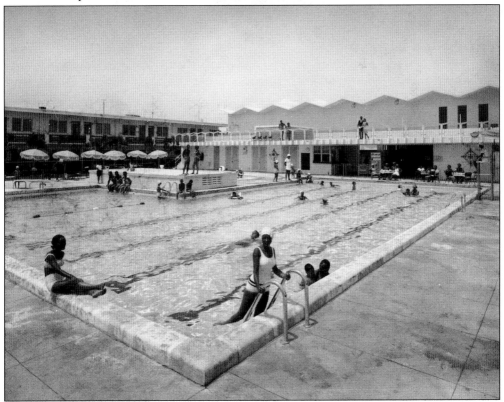

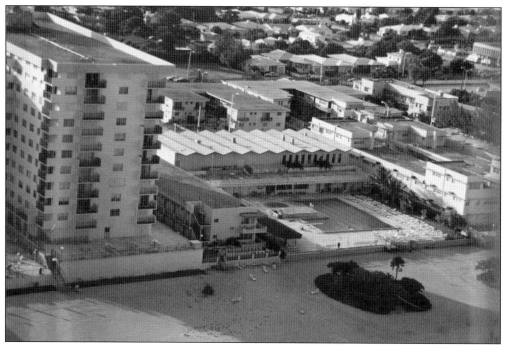

Looking west from the beach, this view shows the full extent of the center's beachside amenities. Besides a snack bar, the center offered meeting and party rooms for residents' use.

In addition to its interior facilities, the new center's exterior features include a wading pool (right), a swimming pool, and a snack bar for the enjoyment of residents and their guests. There are plans to eventually add a second floor to the building. (Courtesy Town of Surfside.)

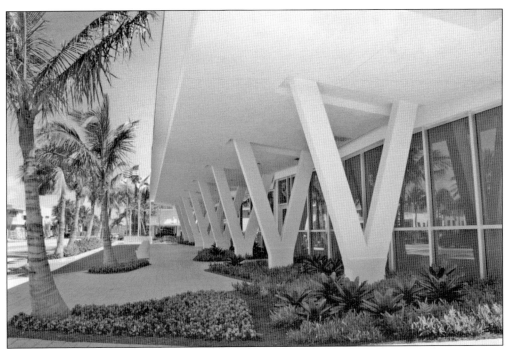
The new community center has a series of V-shaped columns supporting the roof of the structure. This photograph looks north, with Collins Avenue at left. (Courtesy Town of Surfside.)

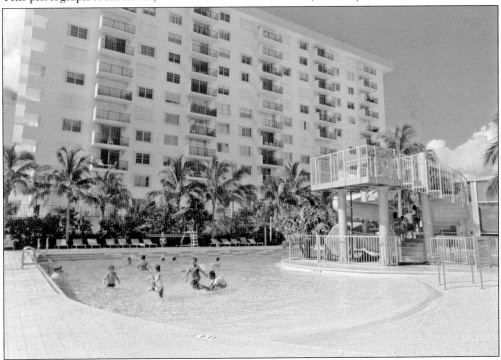
A southward view of the pool area shows children having fun at the shallow end. With lifeguards on duty during operating hours, the pool is a magnet for the town's kids and their friends. (Courtesy Town of Surfside.)

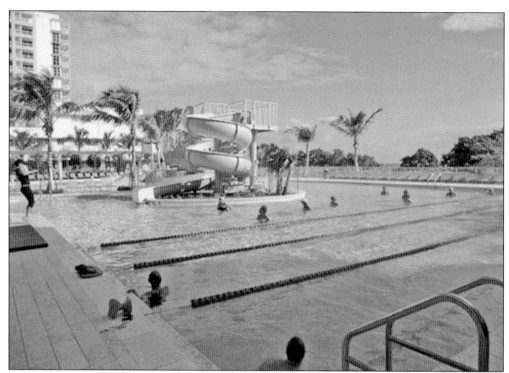

The water slide is just one of the aquatic offerings available at the new center, where swimming lessons are now offered as well. (Courtesy Town of Surfside.)

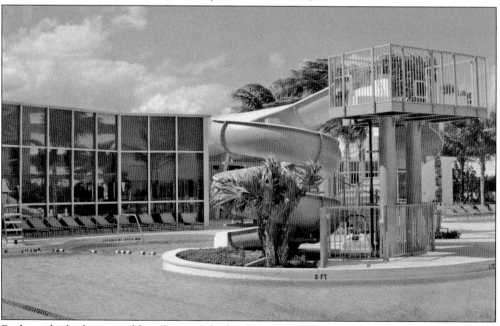

Built to the highest-possible safety standards, the water slide's **steps and platform** are carefully protected to limit the possibility of accidents. In today's world, **liability and accident** prevention are always an important consideration in designing and building public **swimming** pools. (Courtesy Town of Surfside.)

Seven
Hotels and Motels

Unless built as a strictly residential community, most cities and towns that have ocean or other water frontage will generally allow hotel or other commercial construction on that property.

While some individuals may feel that nothing should ever be built facing the water, particularly if it blocks the view from a street, many recognize that not only do those properties attract visitors but they also add to the tax base, which is certainly the case in Surfside. The town's oceanfront hotels, motels, and condominiums, as well as those on the west side of Collins Avenue and on both sides of Harding Avenue, provide no small percentage of Surfside's tax revenues. Fortunately, many of the guests and residents happily spend their money in town, which brings an influx of tax dollars that the fiscally conservative town council uses for the benefit of both residents and visitors.

Interestingly, there appears to be no absolute record of when the first hotel or motel was built in Surfside. However, the town's 75th anniversary publication does contain information on several historic structures and specifically refers to the Nichols West Apartments at 9560 Collins Avenue and the Van Rel Apartments at 9578 Collins Avenue, both of which opened around 1947. Additionally, the Coronado Hotel at Eighty-eighth Street and Collins Avenue might have been the first oceanfront hotel built in the town.

Today, Surfside's hotels and motels are interspersed with condominiums on both sides of Collins Avenue, but the big name remains the Surf Club, which will take center stage in Surfside's social and civic circles with its emergence as a major hotel, condominium, and club. The new Surf Club will be a major attraction, both in its interior features and its architecture, and despite the exclusivity of the past, all who come to the club will be warmly and graciously welcomed.

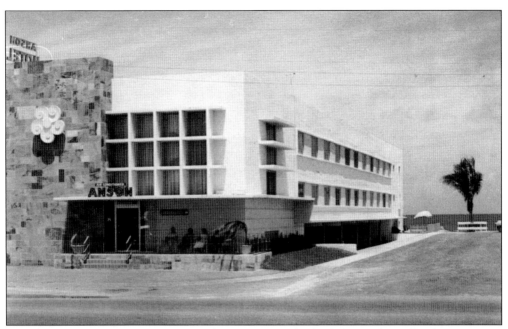

The Anson Hotel, which featured a coffee shop, was located at 9501 Collins Avenue. Like a number of the smaller hotels and motels, the Anson is now long gone.

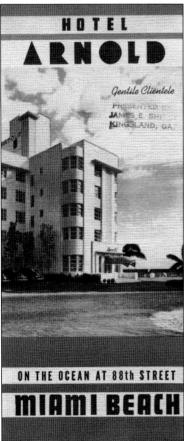

According to this brochure, the "exclusively gentile" Hotel Arnold was located "on the ocean at 88th Street." The hotel was sold shortly after this brochure was printed, and it became the Coronado, which also restricted Jewish patrons.

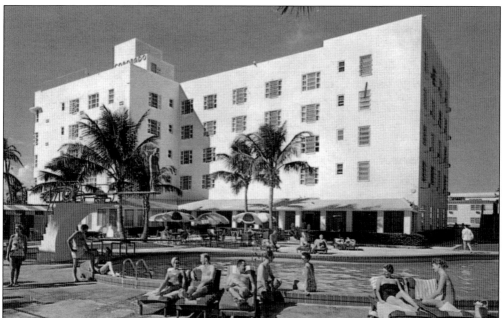

The Coronado, the successor to the Hotel Arnold, was the first hotel north of Miami Beach. Above, a poolside view of the Coronado presents an inviting retreat. Like its predecessor, the Coronado prided itself on catering to a "gentile clientele," made eminently clear on the left brochure. The brochure at right was created somewhat later and featured seven full-color images. It is clear that the exclusion policy had not changed, with the phrase "catering only to a carefully restricted clientele" now appearing on the back cover.

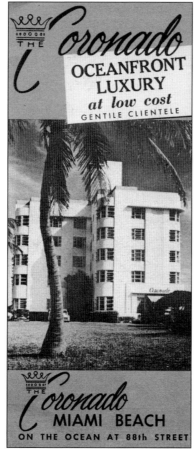

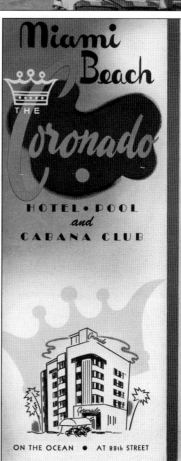

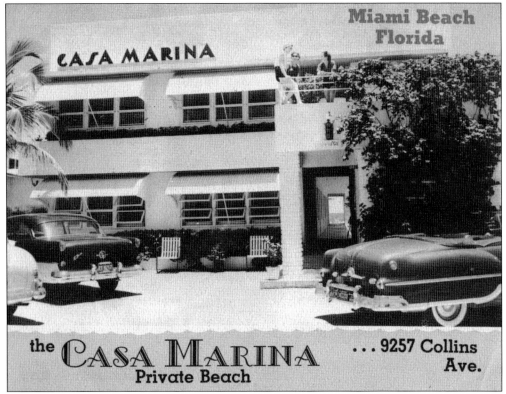

The Casa Marina at 9257 Collins Avenue made it clear that it catered to an exclusive patronage: "Our selected clientele returns year after year."

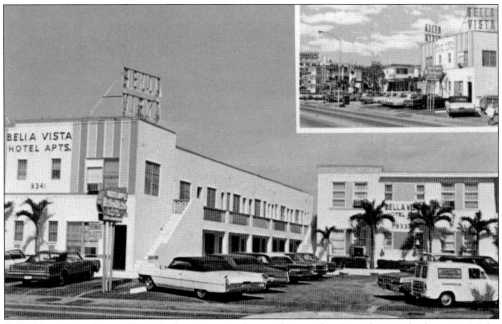

Bella Vista Traveleze at 9341 Collins Avenue featured "casual informality as the keynote." Like so many of the Surfside inns, the Traveleze benefitted from its repeat clientele.

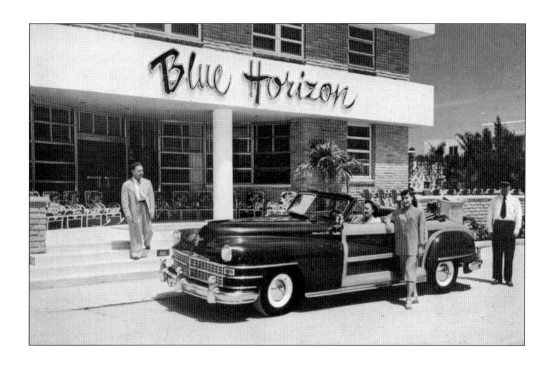

The Blue Horizon was one of Surfside's pioneer hotels. Sometime in the late 1940s or early 1950s, the hotel presented the promotional image above of guests arriving in a woody, with a bellman at the ready. Although interior views of Surfside hotels are indeed rare, the photograph below depicts the cocktail lounge at the Blue Horizon.

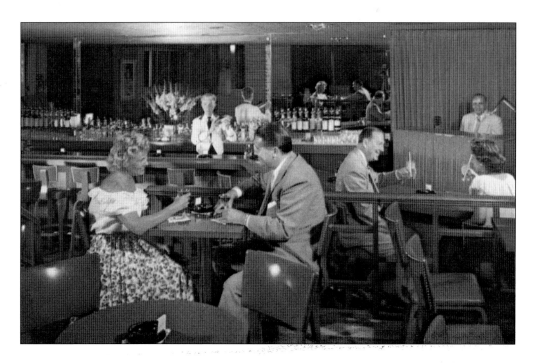

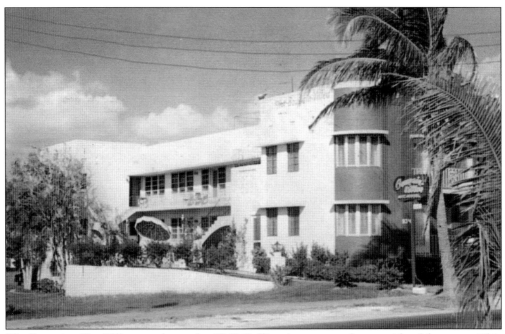

The Bougainvillea Villas were located at 9340 Collins Avenue, on the east side of the street. This 1950 view is a good representation of Surfside's smaller apartment-style hotels.

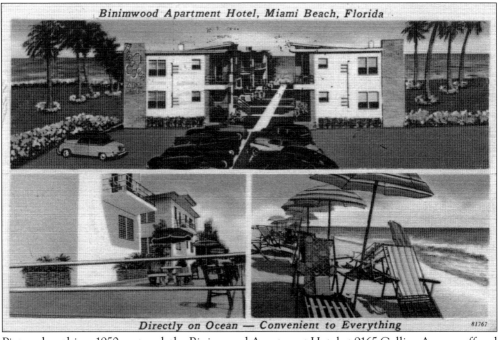

Pictured on this c. 1950 postcard, the Binimwood Apartment Hotel at 9165 Collins Avenue offered "exquisitely furnished apartments." With such unusual monikers, it is a mystery how some of the hotel names were devised.

At right is the cover of a four-page promotional pamphlet for the Crillon at 9569 Collins Avenue, just below Bal Harbour. Dated December 20, 1958, the pamphlet's interior pages include five pictures of the hotel and its facilities, along with three more shots on the back cover, plus a directional map. The Crillon postcard below advertised "100% air-conditioned rooms."

the Crillon
OCEAN FRONT APARTMENT HOTEL
"Your Home Away from Home"

9569 COLLINS AVENUE MIAMI BEACH, FLORIDA
DEC 20 1958

FOR THE TIME OF YOUR LIFE -
come to the Crillon. Enjoy the luxury of one of America's newest and finest ocean-front hotels . . .

More and more people are finding Miami Beach's all-year-round weather ideal and always tempered by gentle, cooling Gulf Stream breezes at the Crillon. And the balmy tropical nights are simply gorgeous!

Here you can rest and relax in casual comfort . . . or fill every sunny moment with fishing, golf, tennis, bathing, boating, and almost every type of healthful recreation. And as each sun-filled day gives way to fun-filled nights, romance is everywhere . . . cocktails in good company . . . dinner by shimmering waters . . . dancing under star-studded tropical skies . . . entertainment . . . enchantment!

Here is a territory steeped in tradition, rich in history. You can visit marine gardens, famous springs, the Everglades, exotic bird sanctuaries, Indian reservations, alligator farms, and many historical places.

The Crillon is brand new and recently completed. Its modern facilities and appointments are unexcelled. It is completely air conditioned.

It has one of the finest salt water pools. It is on the ocean . . . away from the congested area . . . yet there is a complete shopping center only a block away.

We suggest an early reservation. Join with your family, or friends, in making this the best vacation ever. We're sure you will find it inexpensive but highly rewarding - in rest and health - in spirit - in genuine enjoyment!

Cordially yours,
CRILLON HOTEL

COMPLETE HOTEL SERVICE • FULLY AIR-CONDITIONED • SWIMMING POOL AND PRIVATE BEACH • PARKING ON PREMISES

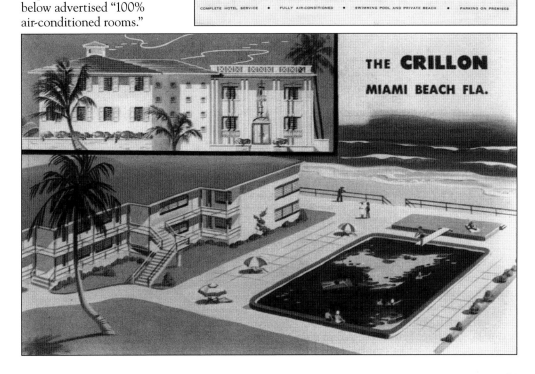

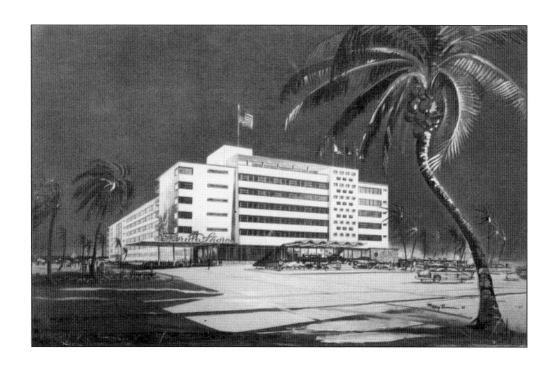

The c. 1956 rendering of the Florida Shores at Collins Avenue and Ninety-fourth Street (above) provides a glimpse of the hotel prior to its opening. Below is a view of the Florida Shores from the Atlantic Ocean beachfront in 1957, shortly after the hotel opened.

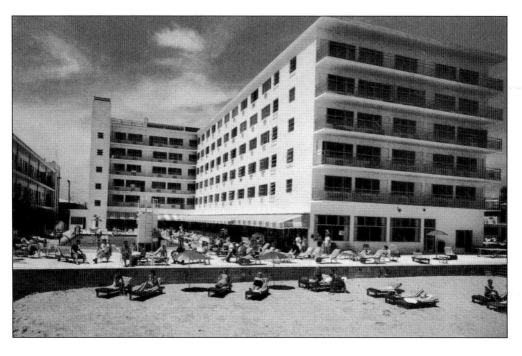

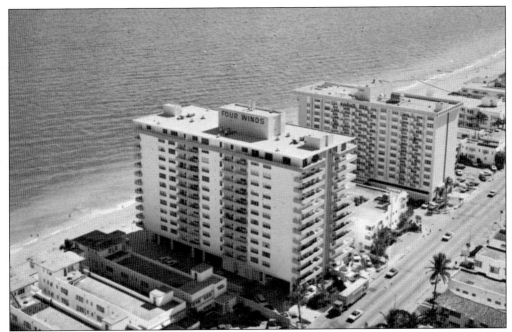

The Edward J. Gerrits Company built the Four Winds at 9225 Collins Avenue, which originally featured "luxury rental apartments." Because initial sales were not as expected, the company also invited short- and mid-term guests to stay in the efficiency apartments.

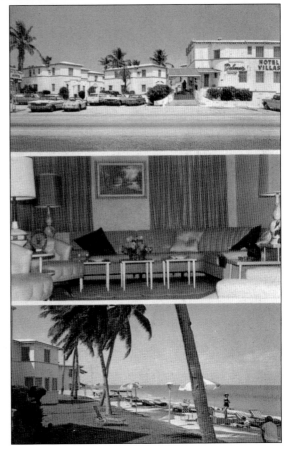

This brochure offers a wonderful triple view of the Del Mar Resort Villas at 9511 Collins Avenue, with images of the front of the hotel, the interior of a villa, and the beachfront of the property.

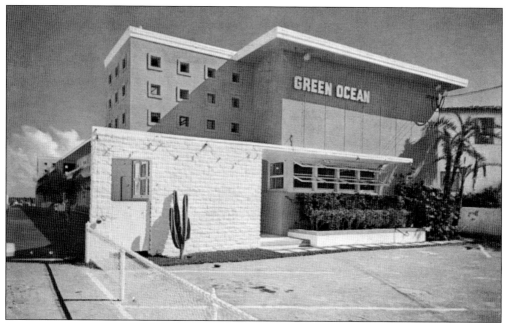

The Green Ocean Hotel Rooms and Apartments are shown in 1950. This property at 9533 Collins Avenue boasted "up to the minute" facilities.

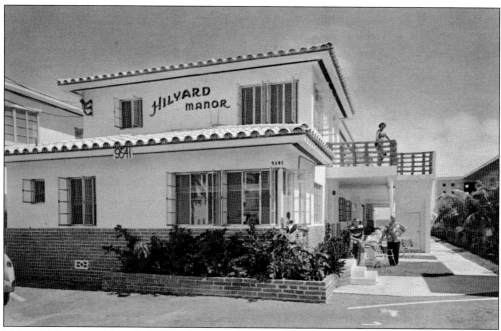

Hilyard Manor at 9541 Collins Avenue advertised a "new building" and "reasonable rates." However, the open windows shown in this view from 1952 clearly indicate that air-conditioning was not one of its features.

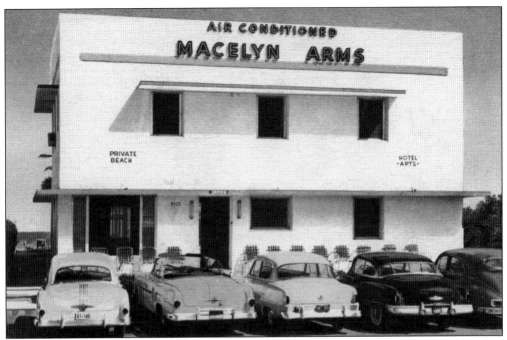

The automobiles in front of the Macelyn Arms at 9325 Collins Avenue are an immediate giveaway as to the era of this photograph, taken in the early 1950s. Also of note are the phrases "hotel rooms (for 2) $25 wk" and "most units air conditioned" found on the postcard.

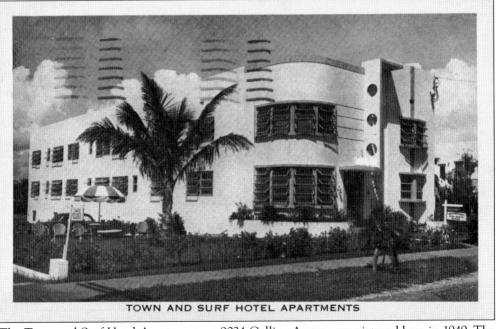

The Town and Surf Hotel Apartments at 9024 Collins Avenue are pictured here in 1949. The variety of caravansaries in Surfside gave prospective vacationers a host of choices for their stay.

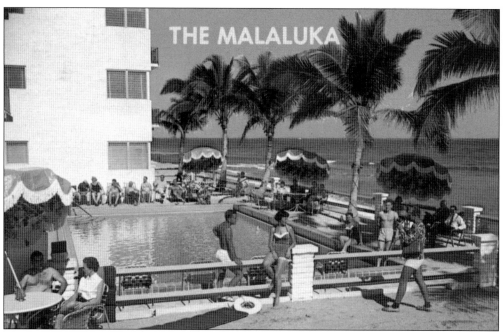

The pool deck at the Malaluka is pictured here in 1966. Located at 9201 Collins Avenue, the hotel offered "ample free parking." Unlike the Miami Beach art deco hotels, almost all the Surfside hotels had sufficient on-site parking.

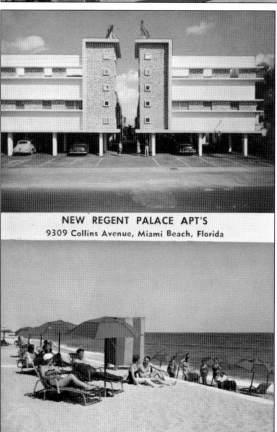

Located "directly on the ocean," the New Regent Palace Apartments at 9309 Collins Avenue offered hotel rooms, penthouses, and covered parking. Here, a front and beachside view are shown.

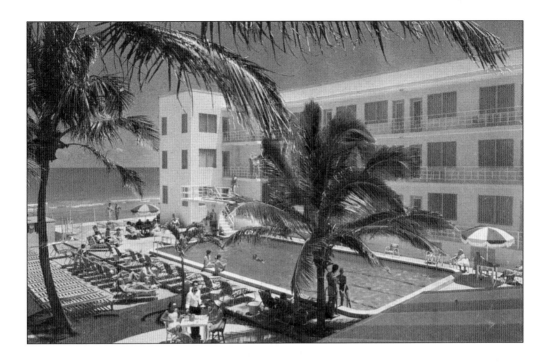

Above, the sundeck at the New Surf Hotel at Eighty-ninth Street and Collins Avenue featured a cabana club and poolside dining. Below, a view of the New Surf pool area from the east end shows the shuffleboard courts on the right, the cabanas on the left, and the chaise lounges in the center.

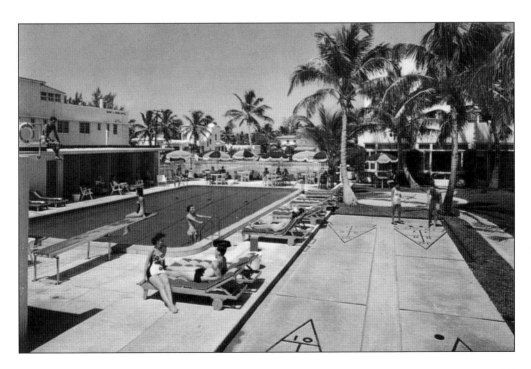

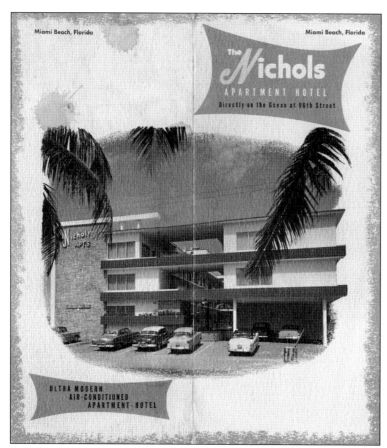

On the ocean at Ninety-sixth Street, the Nichols Apartment Hotel had 50 hotel rooms and apartments with air-conditioning. The cars on the front of the brochure at left date the image to 1953–1954. Below, the sundeck surrounding the kidney-shaped pool at the Nichols was a delightful place for guests to lounge.

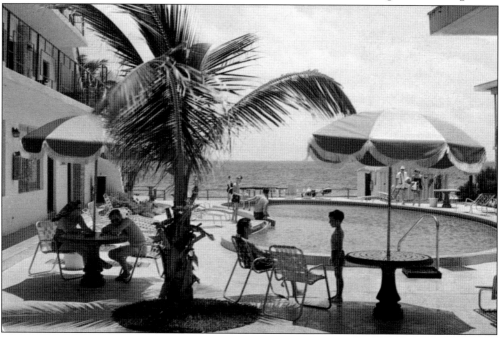

The Ocean Gate at 9551 Collins Avenue was somewhat unique for Surfside in that it had two buildings. Note that the building on the left has an enclosed staircase. The pair of photographs at right shows the hotel from Collins Avenue and the patio area between the buildings in 1959. As shown on the promotional flyer below, Ocean Gate offered hotel rooms with twin beds and a private bath for $3 per day and efficiencies with a Pullman kitchen and a shower bath for a $5 daily rate during the early 1950s.

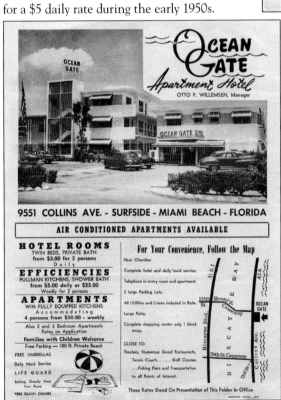

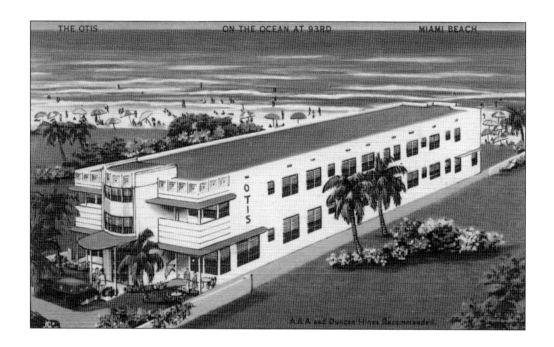

The Otis was located on the ocean at Ninety-third Street. Above, a 1948 rendering depicts the hotel before the addition was built to the south (right side) of the main building. Below, a street-level view of the Otis in 1955 shows the original building with the one-story addition at right.

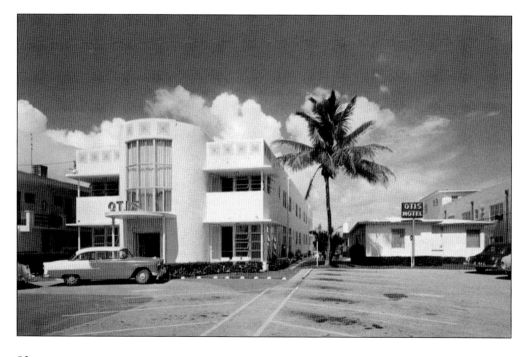

The Pontiac Hotel, "directly on the ocean" at Eighty-ninth Street, featured a rooftop solarium. When the postcard at right was made in 1940, the same people owned the Pontiac Apartments on Indian Creek Drive in Miami Beach. The late 1930s flyer below advertised hotel rooms for $1 per person, with two in a room.

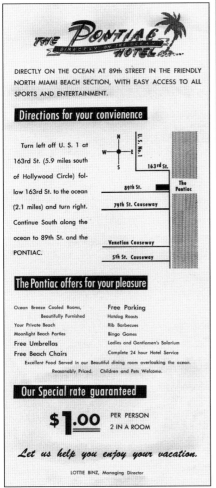

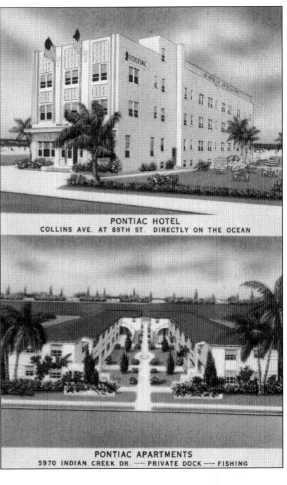

The Palmcrest at 9225 Collins Avenue detailed an interesting selling point, with "all apts. facing south onto a spacious fifty foot lawn." The view south, of course, was only open as far as the next hotel property.

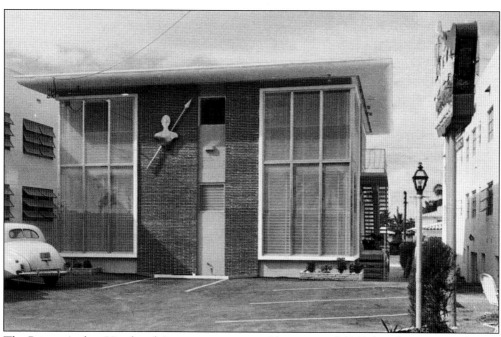

The Prince Arthur Hotel and Apartments, pictured here around 1949, listed "cross-ventilation" as one of its features. That term, of course, meant the hotel was not air-conditioned.

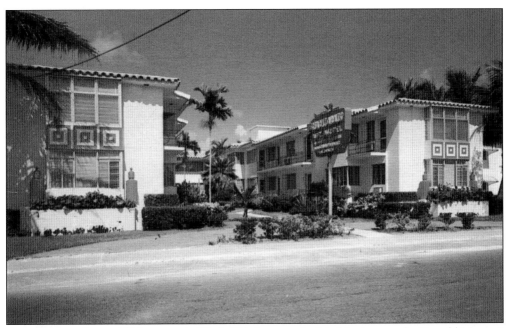

According to this c. 1956 postcard, "Truly 'life is a wonderful thing' — at the Ronald Manor." Located at 9224 Collins Avenue, on the west side of the street, the two-building facility surrounded a courtyard in the center.

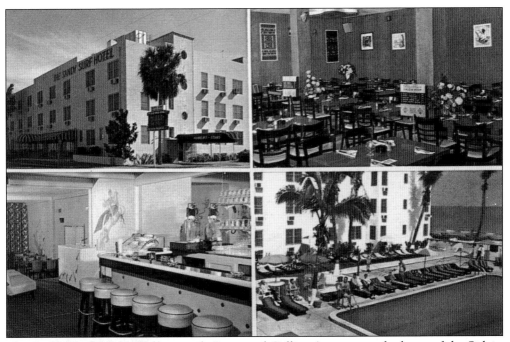

The Sandy Surf Hotel at Eighty-ninth Street and Collins Avenue was the home of the Sirloin Room, a favored dining spot of North Beach and Surfside for some years. Interestingly, very few of the Surfside hotels or motels offered dining rooms to the general public.

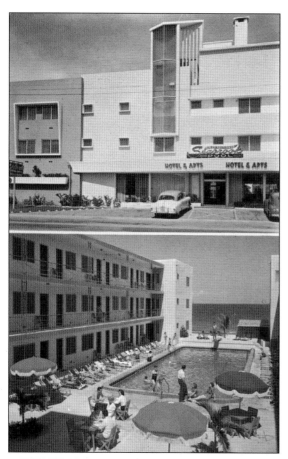

From the mid-1950s to the early 1960s, the Seabrook Resort Motel at Ninety-fourth Street and Collins Avenue was a popular hangout, with a rock and roll band and regular activities for the area's teens and young adults. The divided view at left shows the front of the hotel and the pool deck in the early 1950s. Below, a nighttime view of the Seabrook from about 1962 shows the hotel's parking spaces completely filled.

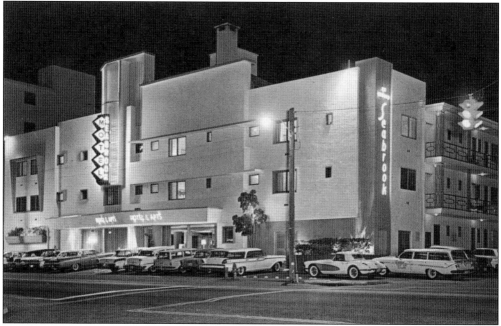

The Seaside Terrace at 9241 Collins Avenue boasted 400 feet of beach frontage, but it did not have a pool. Despite its private beach and other amenities, the hotel lost out on guests who preferred to have the swimming pool amenity as part of their stay.

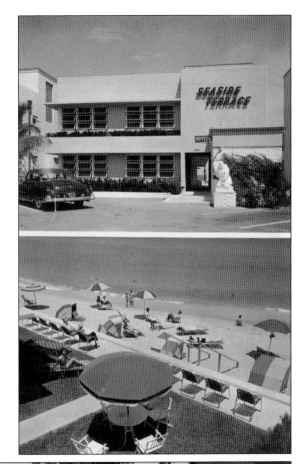

The Seaway Apartments at 9149 Collins Avenue offered "complete hotel service," which generally meant the hotel had housekeeping service on a daily basis.

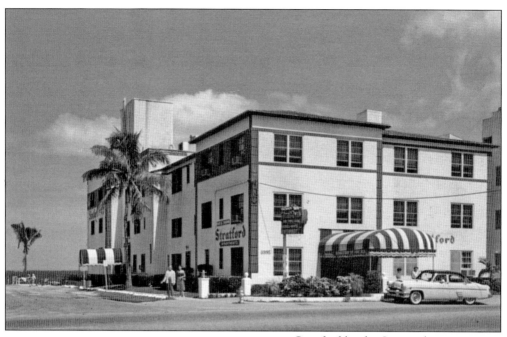

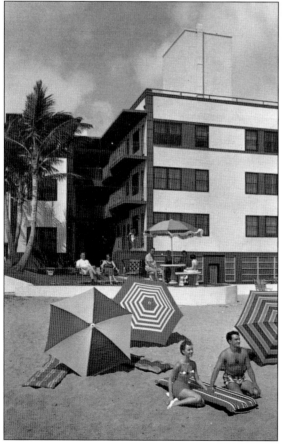

Stratford by the Sea, at the corner of Ninetieth Street and Collins Avenue, prided itself on being "a hotel where informality prevails." At left, a rear view of the Stratford shows the vibrant beach umbrellas and a couple with a raft, ready for a dip in the Atlantic Ocean.

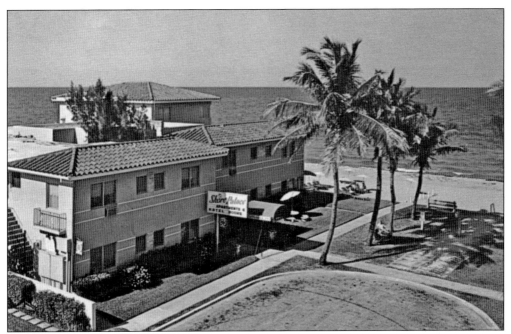

A 1954 postcard shows the Shore Palace. This hotel was another of the properties that advertised itself as being "on the ocean at 89th Street." The Shore Palace offered 17 "deluxe apartments" and "complete hotel service."

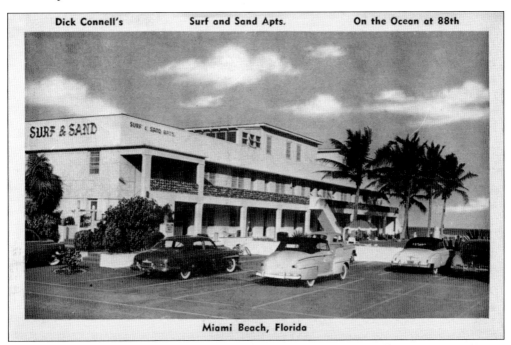

This postcard of Dick Connell's Surf and Sand Apartments is especially interesting, not just because the cars date the image to the late 1940s or early 1950s, but also because the location is listed as Eighty-eighth Street in Miami Beach. However, the hotel, at 8840 Collins Avenue, was actually in Surfside, as Eighty-seventh Terrace was the last street in Miami Beach.

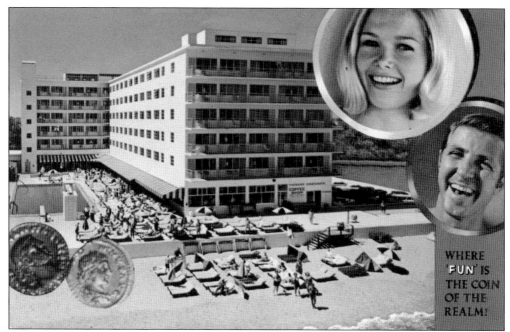

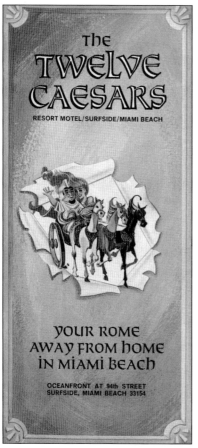

The Twelve Caesars, formerly the Florida Shores Hotel, was the real happening place during the mid-1960s, prior to the opening of the Wreck Bar in the Castaways Motel, the Marco Polo Hotel, and the Newport Hotel, all in Sunny Isles. The 10-page brochure at left detailed all the attributes of a "Roman Holiday" with colorful images and illustrations of sunbathers, the hotel's interior, and of course, the 12 Caesars, all of whom "demanded perfection in their surroundings," according to the brochure.

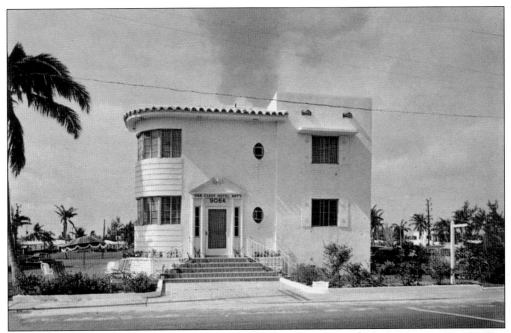

Although relatively small, the Van Cleef, located directly across the street from the fabled Surf Club at 9064 Collins Avenue, was a favorite of both club managers and department heads who stayed there for the season and put up club visitors for short-term stays during the winter.

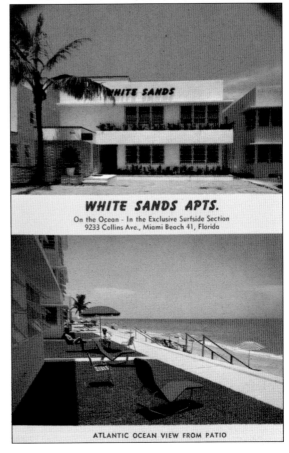

This divided view of the White Sands Apartments at 9233 Collins Avenue shows the front and rear of the building, which offered guests a telephone in each apartment, as well as the availability of radio and television.

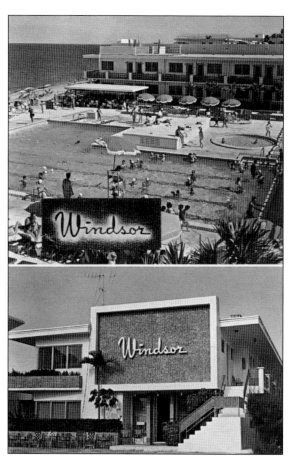

The Windsor, shown here in 1960, was located at 9281 Collins Avenue. This motel featured an extraordinarily large pool for such a modestly sized property.

The 8801 Apartments were located on the site of the former Coronado Hotel and Hotel Arnold. While it was advertised as "apartments," the hotel's promotional materials carefully noted that it offered "complete hotel service."

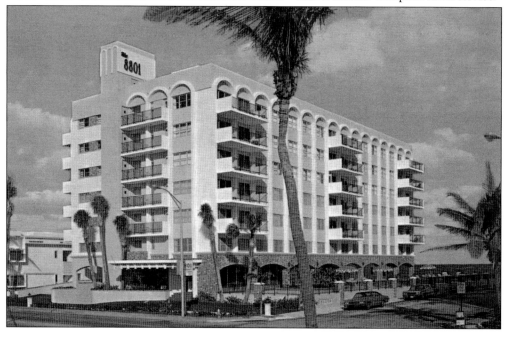

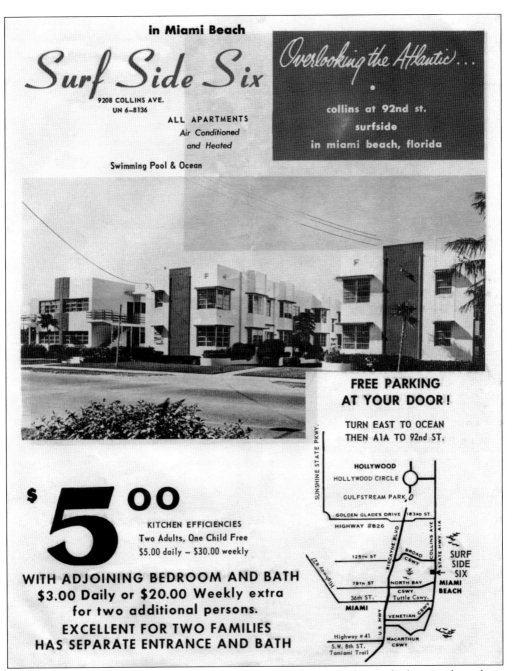

Capitalizing on the name of the popular mid-1960s television show that took place in a houseboat across the street from Miami Beach's Fontainebleau Hotel, Surf Side Six at 9208 Collins Avenue offered kitchen efficiencies for $5 daily, and an adjoining bedroom and bath could be added for $3 more per day.

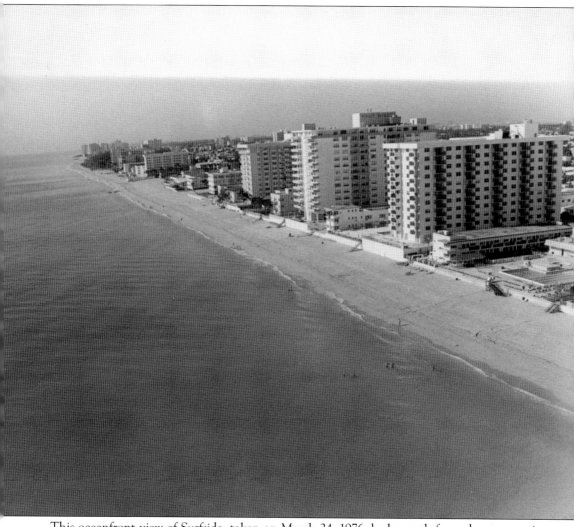

This oceanfront view of Surfside, taken on March 24, 1976, looks south from the community center (far right). The Four Winds at 9225 Collins Avenue is at center, and the Surf Club is farther south on the beach. (Photograph by Robert Berman; courtesy City of Miami Beach.)

Eight

SURFSIDERS

Some famous names have graced Surfside, whether as visitors, residents, store owners, or restaurant patrons, and every one of them seems to have enjoyed their time there.

As noted in chapter six, guests have included Jayne Mansfield, Sonny Liston, Cassius Clay (later, Mohammed Ali), Florida governor Fuller Warren, and numerous other political figures and celebrities.

James P. Wendler, publisher of the *Miami Beach Times* for many years, was Surfside's mayor from 1956 to 1958 and also served on the town council beginning in 1950. Marion Portman served as the town's only female mayor, from 1976 to 1978, and was the first female mayor in all of Dade (now Miami-Dade) County. Mayor Paul Novack, with 12 years in that post from 1992 to 2004, was Surfside's longest-serving chief executive. Mayors have included businesspeople, attorneys, and teachers, and almost all have dedicated themselves to the welfare of the town.

Prolific songwriter Sid Tepper, whose more than 300 songs included 45 for Elvis Presley and such classics as "The Naughty Lady of Shady Lane" and "Red Roses for a Blue Lady," lived in Surfside from 1970 to 2004.

Famed architect Robert Swedroe has resided in Surfside for many years and has designed several of the town's most renowned buildings.

In writing about the people of the community, many more of whom would be mentioned if space were available, the name of Isaac Bashevis Singer must certainly be highlighted. Singer chose Surfside as his longtime home, and he became the 1978 recipient of the Nobel Prize in Literature. He learned of this honor while sitting with friends and enjoying breakfast at Sheldon's Drugs, where he was a daily habitue.

Simply put, great people make a great town, and in as few words as possible, that is exactly what Surfside is.

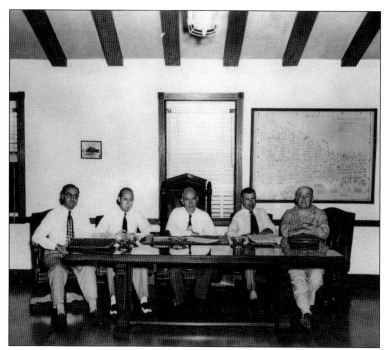

The 1951–1952 council is seated at the original council table in the first town hall. From left to right are councilmen Zeientz and James P. Wendler, Mayor E.P. Fryar, and councilmen David Pollack and John Boehrer.

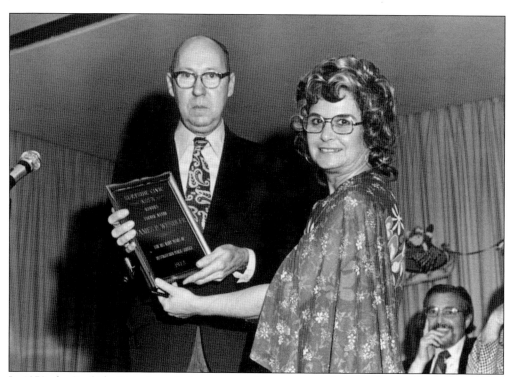

In 1972, the Surfside Civic Association presented former councilman and mayor James P. Wendler with a plaque for his many years of distinguished public service. (Courtesy Dorie Lurie.)

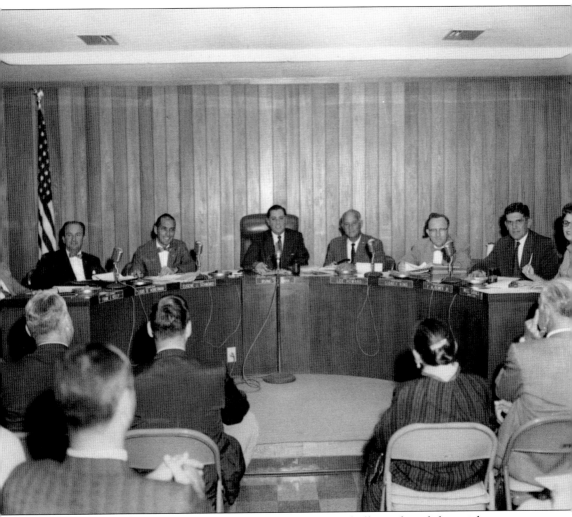

Pictured at an early 1970s council meeting in the new town hall are, from left to right, town attorney Frank J. Kelly, councilmen Louis B. Hoberman and Eugene J. Schwarz, Mayor Irving Schulman, councilmen Lee Howard and Sidney King, town manager F.M. Bowen Jr., and town clerk Miss Carnes.

Longtime Surfside councilman and mayor from 1972 to 1974, Eli M. Lurie was part of the town's political scene for many years. This promotional piece is from what was possibly his first campaign. (Courtesy Dorie Lurie.)

In the 1972 election, Lurie outpolled the other candidates and became mayor. Another of his advertisements is shown here. (Courtesy Dorie Lurie.)

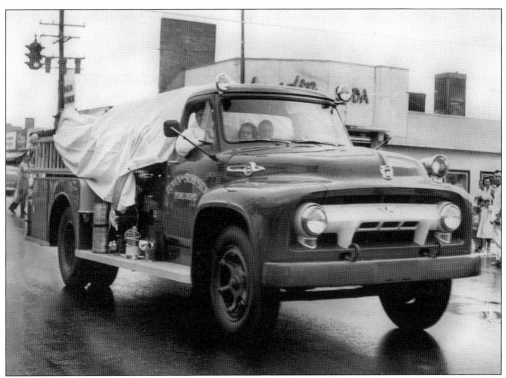

Chief Nilsen (left) is seen riding in the town's fire truck during a parade in September 1954. Next to him in the cab are Judy Zeintz and Michael Kahn, also enjoying the ride.

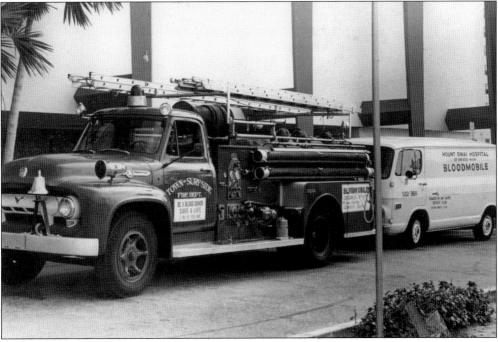

Sometime in the mid-1960s, the fire department participated in the Surfside Blood Drive. The fire engine is shown here with signage for the drive, with the bloodmobile parked behind it.

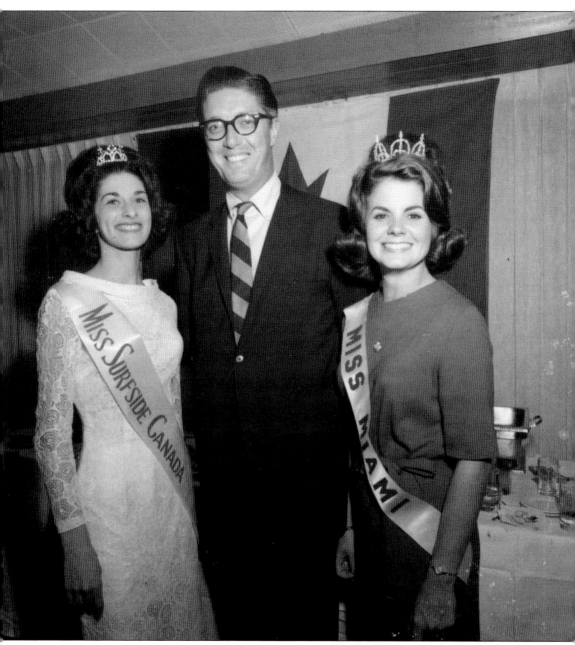

For a good number of years, a large portion of Surfside's tourists and winter residents were Canadians. Thus, the town inaugurated Surfside Canada Week, celebrating their friendship and showing appreciation for their business. Shown at left is Miss Surfside Canada, with Miss Miami at right. The handsome young fellow in between the two beautiful women is Miami's most famous and longest-tenured newscaster, the late Ralph Renick.

Miss Surfside Canada 1973 gets a warm hug and a kiss on the cheek from Mayor Eli Lurie, who was an institution of Surfside politics for many years through the 1970s. (Courtesy Dorie Lurie.)

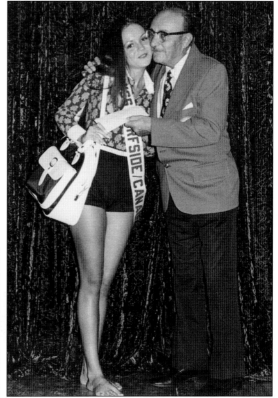

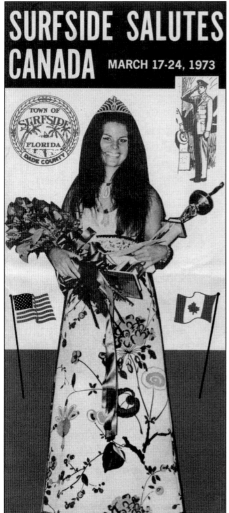

For Surfside Canada Week 1973, the town published this beautiful four-panel brochure highlighting the week's events, among other activities. Surfside Canada Week was a yearly fixture of the town's roster. (Courtesy Dorie Lurie.)

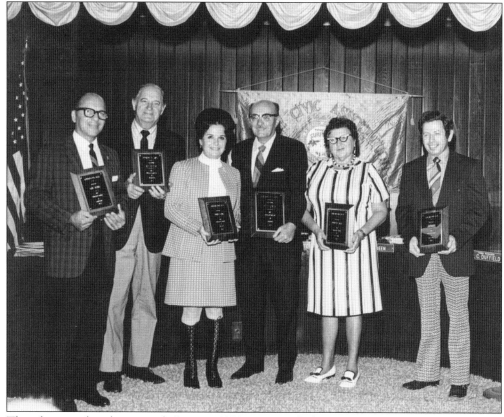

This photograph, taken in early January 1972, is particularly important in Surfside's history, for it shows the outgoing board of the Surfside Civic Association. From left to right are Sam Adams, Sol Hendler, Dorie Lurie (who would become president the next day), Eli Lurie (who resigned to run for town council), Dorothy Rich, and Sol Koenig. (Courtesy Dorie Lurie.)

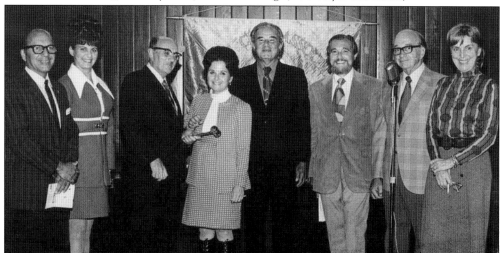

In 1972, the Surfside Civic Association's incoming officers are, from left to right, Sam Adams, Joyce Goldberg (commissioner), Eli Lurie (ex officio), Dorie Lurie (first female president), Max Rosenberg, Irving Kasow, Ted Goldstein, and Angela Spirer. (Courtesy Dorie Lurie.)

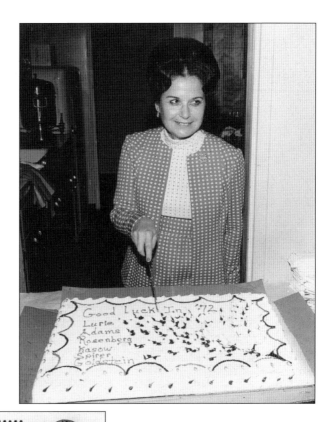

A smiling Dorie Lurie cuts the cake welcoming the new board of the Surfside Civic Association in January 1972. Dorie and her husband, Eli, were active in the association for many years. (Courtesy Dorie Lurie.)

The Surfside Civic Association's *Voice* newsletter of February 1973 expresses the group's unhappiness with the then-current council. Sadly, not one person named in this edition of the *Voice* is alive today. Hence, this is a very important and historical document. (Courtesy Dorie Lurie.)

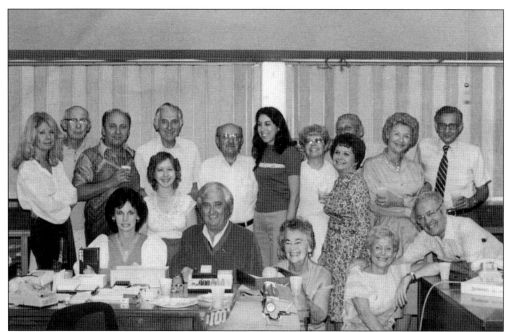

Although the details of this event are unknown today, it must have been a happy affair that took place at the town hall or the community center, as most of those shown are either Surfside employees or volunteers. Identifiable at center is Mayor Eli Lurie (standing fifth from left), and the man in the tie standing at far right is town manager Hal Cohen. (Courtesy Dorie Lurie.)

Eli Lurie was a major force in Surfside politics and civic life for many years. As president of the Taxpayer's Association and a longtime councilman, Lurie served as mayor from 1972 to 1974. (Courtesy Dorie Lurie.)

On December 14, 1970, beloved Florida governor and later US senator D. Robert Graham sent this letter to Dorie Lurie in response to her and the town's concerns about air and water pollution. (Courtesy Dorie Lurie.)

In January 1971, Dorie Lurie, a well-known local conservationist, received this letter from famed broadcaster Arthur Godfrey regarding his interest in bringing the importance of ecology to the American people. (Courtesy Dorie Lurie.)

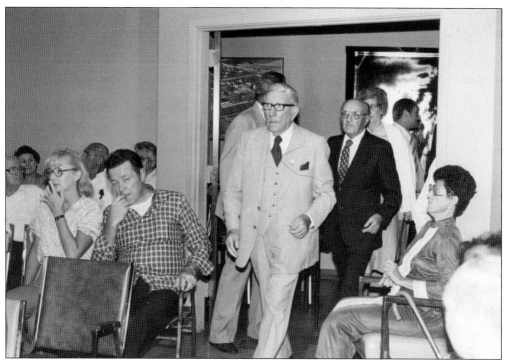

The much-loved former US senator and congressman Claude Pepper was the guest of honor at a Surfside Taxpayer's Association meeting at town hall in October 1980. Former mayor Eli Lurie is seen behind Congressman Pepper. (Courtesy Dorie Lurie.)

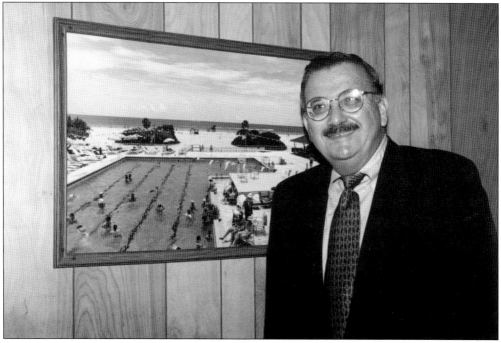

For a number of years, Phil Halpern served as the town's tourism director. Halpern is pictured in his office in the original community center, with a photograph of the pool behind him.

On November 18, 1971, longtime Surfside resident and then vice mayor Carl "Cubby" Green sent this note on the town letterhead to Dr. Leonard Haber to congratulate him on his recent election to the Miami Beach city council.

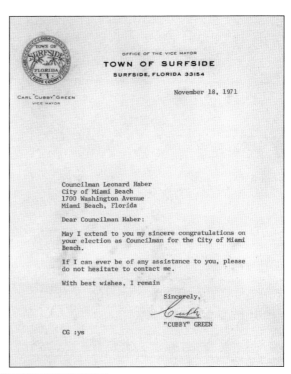

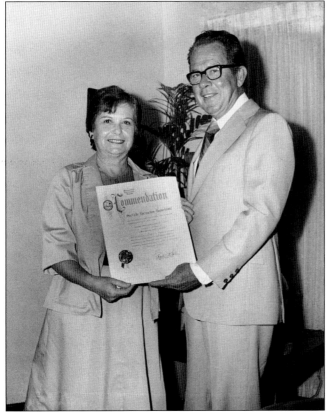

Miami-Dade County mayor Stephen P. Clark presents a county commendation to a representative of the Surfside Recreation Department for working closely with the county on numerous projects beneficial to both the county and the town.

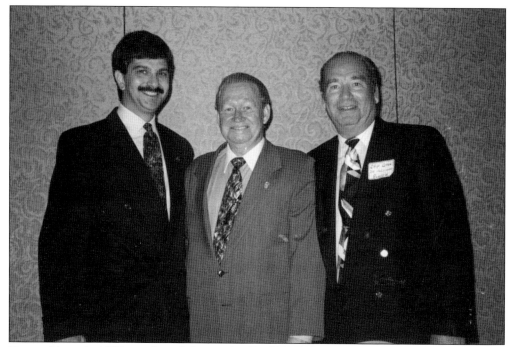

Pictured here in 1996 are, from left to right, Paul Novack, mayor; Terrill Williamson, police chief; and Chip Cohen, public works director. Novack was the longest-serving mayor in Surfside history. (Courtesy Paul Novack.)

Mickey Novack, mother of longtime Surfside mayor Paul Novack, served as vice mayor from 1979 to 1980. She was active in Surfside politics and civic groups for many years. (Courtesy Paul Novack.)

Joining "Mr. Recyclo," Allison Novack, daughter of Mayor Paul Novack, works hard to convince Surfsiders to recycle. Although this photograph was taken in 1996, the identity of superhero Mr. Recyclo remains unknown. (Courtesy Paul Novack.)

As an active member of multiple civic organizations, Dana Kulvin, wife of Mayor Daniel Dietch, is a Surfside stalwart and a true Surfside booster. Kulvin was co-chair of Surfside's 75th anniversary celebration in May 2010, as well as co-editor of the town's anniversary booklet, published that year. (Courtesy Mayor Daniel Dietch.)

A lifelong Surfsider, Joseph "Joe" Graubart has served the town in many capacities, including as a member of the town council and as vice mayor. Graubart received his Driver Education Certificate from the State of Florida in May 1967, as seen below. The course was taken at Miami Beach High School. (Courtesy Joe Graubart.)

DRIVER EDUCATION CERTIFICATE
State Department of Education
Tallahassee, Florida
Floyd T. Christian, Superintendent

Certificate Number 307375
Date of Issue May, 1967

THIS IS TO CERTIFY THAT:

NAME: First Joseph Middle Howard Last Graubart

STREET AND NUMBER: 8909 Irving Avenue

CITY OR POST OFFICE: Miami Beach County Dade State Florida

HAS SUCCESSFULLY COMPLETED A DRIVER EDUCATION COURSE AS DESCRIBED ON THE REVERSE SIDE OF THIS CERTIFICATE.

THE COURSE WAS PROVIDED BY:

Name of Public High School: Miami Beach Senior High School
Mailing Address of High School: 2231 Prairie Avenue

Signature of Student: Joseph H. Graubart
Signature of Principal: Solomon S. Lichter
LICENSE

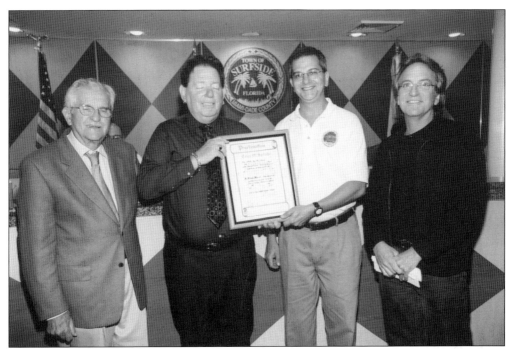

In 2004, the town presented Miami Beach High School teacher and Surfside resident Gary Glick with a proclamation honoring his years of service to both the municipality and the high school. From left to right are Sol Lichter, Glick, Mayor Paul Novack, and Vice Mayor Joe Graubart. (Courtesy Paul Novack.)

Perhaps Surfside's most internationally renowned resident, the late Isaac Bashevis Singer, famed author, philosopher, and Nobel Prize winner, loved the town and made it his home for many years. The cover of the 2004 book honoring Singer has been reproduced here with the permission of publisher Library of America.

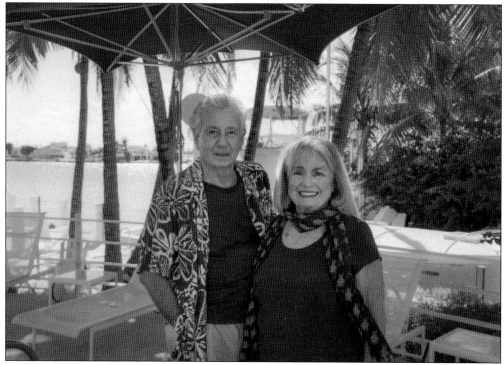

Robert M. and Rita Swedroe are pictured here behind their home in Surfside. Robert is a world-renowned architect with credentials that place him in the top tier of America's foremost practitioners in the field. (Courtesy Robert M. Swedroe.)

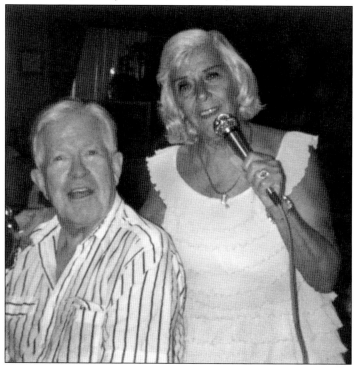

Known as "the Girl with a Thousand and One Songs," Hazel Lee has lived in Surfside for most of her adult life. After owning several nightclubs and raising two wonderful children, Lee is still singing and crooning today as a living Surfside legend. (Courtesy Hazel Lee.)

Surfside is not just a wonderful town in which to live; it is also a fine place to work, as evidenced by this group of dedicated public works employees, each of whom boast over three decades of service. From left to right are Hector Perez, 30 years; Edner Mehu, 32 years; and Gaspar Matos, 32 years. (Courtesy Town of Surfside.)

Longtime public works employee Hector Perez worked at Sheldon's Drugs on the corner of Ninety-fifth Street and Harding Avenue prior to coming to work for the town, which is famous for its ceramic turtles. Perez is shown with several of the sculptures in front of the community center. (Courtesy Town of Surfside.)

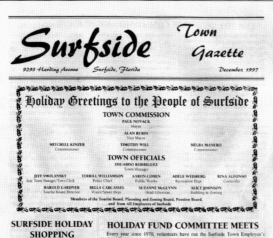

The December 1997 issue of the *Surfside Town Gazette* brought holiday greetings to Surfsiders from the town commission and town officials. Harold Gardner, tourist board director, was one of South Florida's most famous names in tourism and promotion, having worked as public relations director at the Fontainebleau Hotel in Miami Beach from the time it opened in 1954 until 1976, when he became director of Miami Beach's Tourist Development Authority.

This is the 75th anniversary issue of the Town of Surfside *Gazette*. Published in May 2010, it is considered a major Surfside collectible, along with the 75th anniversary booklet. (Courtesy Joseph Graubart.)

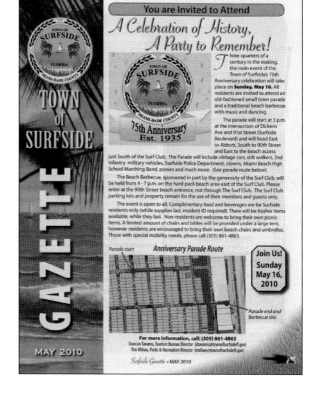

Nine

OUR FRIENDS AND NEIGHBORS

Only two incorporated entities are contiguous with Surfside: Miami Beach to the south and Bal Harbour Village to the north. Two others, Indian Creek Village and the town of Bay Harbor Islands, can only be reached by bridges, both crossing the northern reaches of Indian Creek.

As noted in chapter three, by early 1935, Miami Beach had expressed interest in extending its northern boundary all the way to Ninety-sixth Street, which included all of what would become Surfside. Thus, members of the Surf Club decided to incorporate the Town of Surfside in that year. Bearing no animosity, Miami Beach and Surfside, which share the border of Eighty-seventh Terrace, maintain a close and vital relationship today. In fact, Miami Beach often sends fire or police units to assist Surfside when necessary. Most Surfside children attend high school in Miami Beach, and many Surfsiders frequently patronize its businesses. As with its other neighbors, Surfside's relationship with Miami Beach is close to familial.

Bal Harbour Village was incorporated in 1947, initially as a completely restricted community in which Jewish people were not welcome. That dynamic has totally changed, and Bal Harbour, with its famous shopping center, beautiful residential area, and fine hotels and condominiums, is as desirable a place to live as Surfside. Sharing Ninety-sixth Street as their mutual border, it is but a walk across the street from the upscale shopping and fine dining on Harding Avenue to the Bal Harbour Shops.

The town of Bay Harbor Islands is made up of successful businesses, restaurants, apartment houses, and condominiums, as well as the Ruth K. Broad Bay Harbor K–8 public school.

The last of Surfside's neighbors, but certainly not least, is the magnificent residential island of Indian Creek Village. With only 44 private homes, that municipality is possibly the single wealthiest community in the southeastern United States, if not the entire country. Like its three 33154 neighbors, Indian Creek Village has a very low crime rate. Living there or in any of the other three communities is not only quite safe but also provides a lifestyle with access to amenities found in few other places in America.

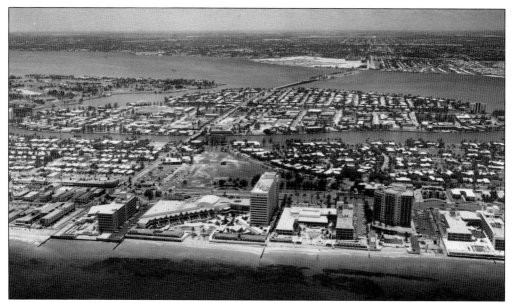

This absolutely marvelous aerial view, taken by former Miami photography firm Tierney & Killingsworth in 1959, is one of the finest photographs of all the communities in the 33154 zip code, with the mainland in the background. Surfside is at left, and the Americana of Bal Harbour is directly in front of the camera, with the Singapore Hotel to its left and the Balmoral to the right. The site of Bal Harbour Shops, directly behind the Americana and the Singapore, is still completely vacant. Bay Harbor Islands is on the other side of Indian Creek, and Indian Creek Village is visible at left.

Surfside's closest commercial neighbor to the south was Miami Beach's Biltmore Terrace Hotel, at the corner of Eighty-seventh Street and Collins Avenue. The hotel was demolished to make way for condominiums.

On February 19, 1969, a Miami Beach photographer took this aerial view of the North Shore Open Space Park, looking north toward Surfside. The first high-rise is the Holiday Inn at Eighty-seventh Terrace, previously shown in its Biltmore Terrace incarnation.

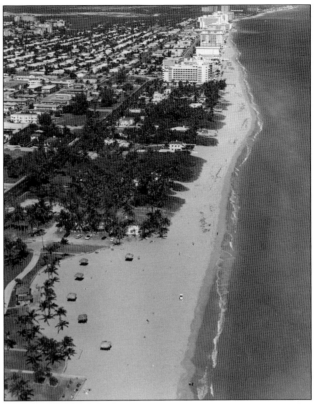

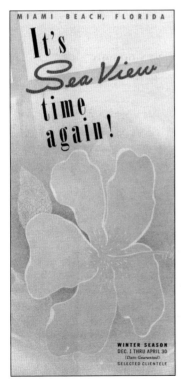

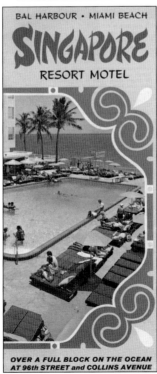

From its founding until 1958, Bal Harbour was resolutely restricted, with Jewish people neither permitted to purchase homes nor stay at hotels in the village. The Sea View made its exclusivity clear with the words "selected clientele" on the cover of its brochure. Finally, the Whitman brothers were able to convince Bal Harbour's village council to allow the building of the Tisch brothers' Americana Hotel at Ninety-seventh Street and Collins Avenue. The Singapore was built following the opening of the Americana, neither of which were restricted properties. With the Balmoral also welcoming all guests, the days of excluding people based on their religion were clearly numbered.

Three of the people who were highly responsible for bringing Bal Harbour, as Stanley Whitman (left) stated to the author, "kicking and screaming into the twentieth century" are shown at a reception celebrating the 1986 opening of the new Saks Fifth Avenue store at Bal Harbour Shops, owned by the Whitman family. In the center is the late Sol Taplin, longtime Bal Harbour councilman and builder of the Harbour House Apartments, and on the right is Bal Harbour mayor Rich Olsen.

As gracious and elegant as she was beautiful, the late Estelle Stern Spiegel became Bal Harbour's first female mayor and served the village in that capacity from 1989 until 1999.

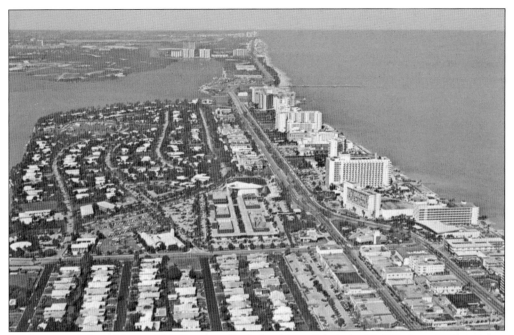

Looking north from Ninety-fifth Street in Surfside, this aerial view of Bal Harbour Village shows the entire community in 1990. Collins Avenue is the main drag, running north and south in front of the hotels and condominiums, Bal Harbour Shops is in the center foreground, and the Singapore and American Hotels are the first high-rises at right.

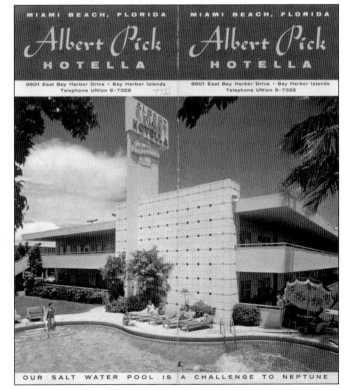

Famed restaurant supply magnate Albert Pick, who also owned a small chain of hotels in the Northeast and Midwest, loved South Florida, and in the mid-1950s, he built the Albert Pick Hotella at 9601 East Bay Harbor Drive, just over the Indian Creek bridge from Surfside. It became his favorite property, and after meeting and marrying his wife, Gertrude, he honeymooned at his own hotel.

For many years, the town of Bay Harbor Islands owned and operated its own toll bridge, crossing Biscayne Bay from Ninety-sixth Street on the Miami Beach side to Northeast 123rd Street on the Miami side. Taken from the south side of West Broadview Drive, this c. 1953 photograph looks west toward the open Broad Causeway drawbridge.

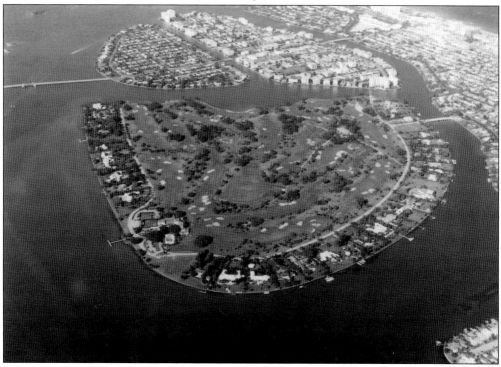

Here is a view of the magnificent Indian Creek Village captured from the air. With 44 private homes surrounding Indian Creek Country Club and its golf course, the only automobile entrance to the village is the bridge at right connecting residents to Surfside.

Ten

Taking Surfside into the Future

Surfside's mayor, Daniel Dietch, is a longtime Surfside resident and booster. Dietch was elected mayor in March 2010, just in time to lead the town's 75th anniversary celebration in May of that year. Incidentally, Dietch's wife, Dana Kulvin, co-chaired the event with Ricardo Mualin.

The town's commission includes Barry Cohen, Michelle Karukin, Marta Olchyk, and Eli Tourgeman, vice mayor.

When Michael Crotty resigned in November 2014, John Di Censo stepped in as interim town manager. From Buffalo, New York, Di Censo came to Miami Beach in 1976, eventually becoming a division chief with that city's police department. After retiring in 2007, he became the assistant chief in Surfside. Di Censo served as interim town manager until Guillermo Olmedillo was appointed to the position on January 5, 2015.

As Surfside's tourism, economic development, and community services director, Duncan Tavares is responsible for the town's promotions and advertising, as well as business outreach.

Chief of Police David Allen joined the Town of Surfside as interim police chief in October 2006. He was then appointed the permanent police chief on March 1, 2007. Prior to coming to Surfside, Chief Allen was a division chief with the City of Miami Beach. His vision is to build the Surfside Police Department into a leading law enforcement agency through accountability, quality hiring and training practices, and the highest level of professional and courteous service to the community. Suffice it to say that, under his leadership, the department is well on its way to fulfilling those goals.

Other members of Surfside's professional and management staff include Sandra Novoa, town clerk; Dawn Hunziker, executive assistant to the town manager; Yamileth "Yami" Slate-McCloud, human resources director; Linda Miller, town attorney; Joseph S. Kroll, public works director; and Joe Damien, code compliance officer. Naturally, the town's other employees are equally important to its continued success, and at least three of them have been employed by the town for 30 or more years.

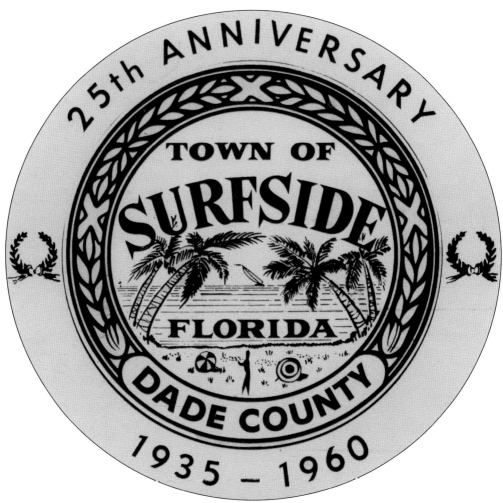

In 1960, the town celebrated its 25th anniversary, the emblem for which is shown here. At that time, "the future" of Surfside was just beginning, and the council and residents were looking forward to many more great years.

Mayor Daniel Dietch is a longtime Surfside resident. With a master's degree from Cornell University, Dietch is an unrequited Surfside booster committed to the continual improvement of the town's infrastructure, as well as its residents' quality of life.

Commissioner Barry Cohen is a graduate of the University of Miami, where he received a business degree. While in college, he owned and operated a hospitality supply business. Cohen later received his Juris Doctor degree from Pepperdine University School of Law in California and has been a practicing attorney for almost 30 years.

Commissioner Michael Karukin has been involved in Surfside's policy direction since 2008. After serving on the Charter Review Board, he was elected to the Surfside Commission in 2010, then reelected in 2012 as vice mayor. Karukin has worked as a clinical research scientist in the pharmaceutical industry for more than 30 years. He is a physician's assistant with bachelor's degrees in physiological psychology and medicine from the University of Florida and a doctorate degree in health services administration from Walden University.

Commissioner Marta Olchyk was born in Cuba. In 1960, she immigrated to Dallas, where she lived until 2000. During that time, she earned a master's degree from Texas Woman's University and a doctorate degree from Texas Christian University. Her professional career included teaching Spanish and Latin American civilization at both the high school and college level for eight years. She then became a federal investigator with the Department of Education and the Equal Employment Opportunity Commission until her retirement in 2003. Olchyk was first elected to the commission in 2011.

Vice Mayor Eli Tourgeman was born in Panama and educated at Long Island University in New York, earning a bachelor of science degree cum laude. His experience in the banking industry and credibility in the community made him a natural choice as a manager of banks on Surfside and Bal Harbour. Currently, he is the president of the Surfside Business Association.

The February 2015 issue of the Town of Surfside *Gazette* featured newly named town manager Guillermo Olmedillo on the cover. Olmedillo, pictured here with his wife, Gladys, accepted the position and began work on January 5, 2015.

Duncan Tavares is the tourism, economic development, and community services director for Surfside. Tavares's office in the community center is a beehive of activity, with the many duties assigned to him.

Surfside's highly regarded chief of police, David Allen, is pictured above. As a police commander or chief for many years, Chief Allen is highly respected by his department personnel, as well as his colleagues in other departments. Under his direction, the police department has received national accreditation and enacted a large number of community engagement programs. The brochure at left, explaining the services provided by the department to the community, is just one example of the exemplary work of the police department through the efforts of Chief Allen and his team.

About the Author

Seth H. Bramson is Miami's foremost historian. He is America's single most published Florida history book author, with 18 of his 23 books dealing directly with the villages, towns, cities, counties, people, and businesses of the South Florida Gold Coast.

As the company historian of the Florida East Coast Railway, he is the only person in the country to bear that title with an American railroad, and his book *Speedway to Sunshine* is the official history of that famous line. His collection of FEC Railway and Florida transportation memorabilia is the largest in the world—larger than the state museum's collection and larger than the Flagler Museum's collection.

A graduate of Cornell University's famed School of Hotel Administration, he holds master's degrees from St. Thomas University and Florida International University, both here in Miami. He is adjunct professor of history and historian in residence at Barry University, adjunct professor of history at Nova Southeastern University's Lifelong Learning Institute, and adjunct professor of history at the University of Miami's Osher Lifelong Learning Institute. In addition, he is historian in residence at FIU's Osher Lifelong Learning Institute.

The founder of the Miami Memorabilia Collectors Club, he maintains the largest private collection of Miami memorabilia and Floridiana in the country.

He is now working on his 24th and 25th books, one of which will be the centennial history of Miami Beach, and the other will be the history of Miami Beach High School.

Additionally, he is the author of more than 200 articles on South Florida local and Florida transportation history, including six in juried or refereed publications.

He has appeared as a featured guest or commentator on Florida history programs on A&E, Discovery Channel, Florida Public Broadcasting, Fox's FX *The Collectibles Show*, the History Channel, the Learning Channel, and Turner South Network, as well as all six local Miami television stations.

Nationally recognized as Florida's leading transportation historian and the Miami area's preeminent local historian, he has been frequently quoted in newspapers and magazines throughout Florida, as well as in the *New York Times*, the *Chicago Tribune*, *Bloomberg Business Week*, the *History Channel Magazine*, and *USA Today*.

This is his fifth book for Arcadia Publishing.

Discover Thousands of Local History Books Featuring Millions of Vintage Images

Arcadia Publishing, the leading local history publisher in the United States, is committed to making history accessible and meaningful through publishing books that celebrate and preserve the heritage of America's people and places.

Find more books like this at
www.arcadiapublishing.com

Search for your hometown history, your old stomping grounds, and even your favorite sports team.

Consistent with our mission to preserve history on a local level, this book was printed in South Carolina on American-made paper and manufactured entirely in the United States. Products carrying the accredited Forest Stewardship Council (FSC) label are printed on 100 percent FSC-certified paper.